Little Book of
VIDEO GAMES

70 Classics That Everyone
Should Know and Play

MELISSA BRINKS

RUNNING PRESS
PHILADELPHIA

Running Press
Hachette Book Group
1290 Avenue of the Americas, New York, NY 10104
www.runningpress.com
@Running_Press

Printed in China

First Edition: May 2020

Published by Running Press, an imprint of Perseus Books, LLC, a subsidiary
of Hachette Book Group, Inc. The Running Press name and logo is a trademark of the
Hachette Book Group.

The Hachette Speakers Bureau provides a wide range of authors for speaking events.
To find out more, go to www.hachettespeakersbureau.com or call
(866) 376-6591.

The publisher is not responsible for websites (or their content) that are not owned
by the publisher.

Icons and spot illustrations copyright © 2020 by Getty Images:
Nusha777, MonsterDesignX, LueratSatichob, pressureUA, and greyj
Print book cover and interior design by Rachel Peckman

Library of Congress Control Number: 2019951194

ISBNs: 978-0-7624-9657-0 (hardcover), 978-0-7624-9656-3 (ebook)

RRD-S

10 9 8 7 6 5 4 3 2 1

Contents:
Select a Game

INTRODUCTION:
HOW A GLITCH TAUGHT ME TO LOVE VIDEO GAMES

I don't remember the first video game I played.
It might have been *Super Mario Bros.* or *Duck Hunt* or *Dr. Mario*, or one of any number of arcade games available at the local pizza place. I sank many hours into each of them, but I distinctly remember the moment I fell in love with the medium.

It was an old, kind of crummy, off-road racing game for the PlayStation. I played it religiously at a friend's house, even though I was terrible at it. But one day, something magical happened: I veered off the track and into the fence that kept players within the level boundary. Instead of correcting myself, I kept going and rammed into a corner of that fence, but for once, it didn't stop me—I kept going, driving out over the endless horizon in an infinite loop.

I'm sure I had run into bugs before then, but this glitch, which let me break the rules for fun, was something new. I suddenly became aware that games weren't perfect, and that made them infinitely more interesting. How did

bugs make it in? What kind of people worked on video games? How did the games get made?

From that moment on, my curiosity was insatiable. Unable to afford new game consoles, I read gaming magazines, absorbing the stories behind the games almost as often as I devoured the stories of the games themselves. Video game history is fascinating, a mixture of technological achievement and deeply human tales of passion, curiosity, and betrayal, often as exciting as the sword-slinging adventures of Link or the terrifying journey of Harry Mason.

It's easy to forget that the games that shaped the current industry haven't always existed, that they, too, could be buggy gateways to learning more about a favorite pastime. In this book, I've collected anecdotes about some of the most impactful games in history—not necessarily the most popular, or the best-selling, or my personal favorites, but rather the games that influenced today's hits, forever leaving marks on an enormously significant industry.

Whether you're a seasoned gaming historian or you're just picking up your first controller, I hope these stories will excite you in the same way that the glitch in some racing game whose name I don't even remember did for me.

Tennis for Two
1958

 SPORT **ANALOG COMPUTER**

Pinpointing the very first video game is difficult—numerous tic-tac-toe and chess emulators existed prior to *Tennis for Two*'s creation in 1958, but William Higanbotham's invention is often regarded as the first video game by modern standards.

Higanbotham started his career in radar technology before working at the Los Alamos National Laboratory as part of the Manhattan Project. His team developed ignition and measuring instruments for the first nuclear bomb, but Higanbotham later left the project and dedicated his life to nuclear nonproliferation as a founder of the Federation of American Scientists in 1945. He joined Brookhaven National Laboratory's instrumentation division two years later, where he developed *Tennis for Two*, a tennis simulator, to showcase at one of the lab's annual exhibitions.

Higanbotham hoped that "it might liven up the place to have a game . . . which would convey the message that our

scientific endeavors have relevance for society." He, along with other members of the instrumentation division, created the game in just three weeks, using existing circuits and instructions. They chose not to patent it because Higanbotham didn't think the game was sufficiently innovative. And having been developed with Brookhaven's technology, it would have belonged to the US government rather than to him.

Despite creating one of the earliest known video games, Higanbotham preferred to be known for his work in nuclear nonproliferation.

Tennis for Two was largely forgotten until the 1980s, when David H. Ahl, founder of *Creative Computing* magazine, recalled playing the game as a teen. In a cover story for the magazine, he called Higanbotham the "grandfather of video games." Around six months later, an interview by Frank Lovece that ran in *Video Review* renewed interest in Higanbotham's contributions to the field.

Spacewar!
1962

SPACE COMBAT

PDP-1 COMPUTER

Spacewar! is another contender for the title of first video game. Though it was never commercially available, the game introduced many concepts—unique weapons, a virtual world, physics—that later became synonymous with the medium. Developed by Steve "Slug" Russell, a member of the Tech Model Railroad Club, which many early hackers participated in, *Spacewar!* was one of the first games created for entertainment. Two players control spaceships in orbit around a star with a gravitational pull. Both ships have weapons, and the ultimate goal is to destroy your opponent's ship first.

Russell developed the game with the intent of impressing his friends, and that it did. Because the computer he used to create the game was enormous (roughly the size of three refrigerators) and prohibitively expensive, Russell and others deemed it unnecessary to copyright protect the game. It

was also developed under "hacker ethic," a philosophy of early computer programming that held that computers and the knowledge possibilities they contained should be free to operate and access. *Spacewar!*, as part of that new technology, was available to be played, taken apart, remixed, and studied by others.

As the game grew in popularity, hackers added new modes, such as a realistic starfield, and tweaked Russell's weapon deployment (which included frustrating random explosions) to be more predictable. Others invented variations on the game, spreading its popularity among computer enthusiasts for free. The game was even used to test whether PDP-1 units were functional: programmers would turn on the machines and activate the game to verify that the computers were in working order.

Nolan Bushnell and Ted Dabney, cofounders of Atari, later adapted the game for the arcade, renaming it *Computer Space*. Though a fiscal failure, it was the first commercially sold arcade game.

Pong
1972

 SPORT **ARCADE**

Pong is often recognized by modern standards as the first video game—it was available commercially for both arcade and home use—but its history is contentious. Nolan Bushnell, along with his coworkers at the arcade-game manufacturer Nutting Industries, had played a Magnavox Odyssey game called *Table Tennis* at a trade show. After Bushnell and Ted Dabney founded Atari, Bushnell asked Al Alcorn, a computer scientist and programmer at Atari, to develop his own version of *Table Tennis*—a project that would become the much-beloved *Pong*.

Alcorn's version added some unique features, such as having the ball bounce at different angles, having the speed increase as the game progressed, and a points system. With this competitive two-player angle, *Pong* became so successful that Atari could hardly keep up with orders. Bushnell and Alcorn, struggling to meet demand and unable

to afford skilled workers to produce the arcade machines, offered people at the unemployment office just over minimum wage to build the cabinets. *Pong* became the first commercially successful video game.

However, their success came at a cost. Magnavox filed and eventually won a lawsuit against Atari, forcing them to pay for patent infringement. And the game was such a hit that other companies were quick to clone it and manufacture their own. It's believed that, eventually, Atari owned fewer than a third of the *Pong* and *Pong*-like arcade cabinets.

> The home version, carried exclusively at Sears during the 1975 holiday season, sold over 150,000 copies and became the highest-selling item in Sears's history.

Breakout
1976

 SPORT

 ARCADE

Frustrated with the high cost of producing single-player *Pong* cartridges, Nolan Bushnell offered a substantial bonus to any employee who could redesign the game with the fewest number of microchips—at the time, the average new Atari game contained 150 to 170 chips. Apple cofounder Steve Jobs, then an employee at Atari, asked his friend and fellow Apple cofounder Steve Wozniak to help him do the redesign, offering to split the pay.

The game they developed was *Breakout*, a solo game in which the player breaks bricks by bouncing a ball off a paddle. It took four nights without sleep, but Wozniak and Jobs got the project down to a mere forty-four chips, fewer than a third of the average Atari game. But due to Wozniak's complex and compact chip arrangements, manufacturing was difficult. In the end, the commercial version contained about a hundred chips.

Like many others, the game became a great source of controversy. Jobs didn't share the promised bonus with Wozniak, despite the fact that Wozniak had performed the bulk of the work. Al Alcorn once said that Jobs "never designed a lick of anything in his life. He had Woz do it."

In 1973, Atari granted Namco the rights to distribute in Japan, but Atari would retain manufacturing rights. Unfortunately for Namco, a Yakuza clan began manufacturing counterfeit *Breakout* machines, which soon threatened to crowd out the legitimately licensed Namco cabinets. However, Atari wasn't interested in challenging the counterfeits, so Namco began manufacturing its own rather than distributing Atari-made games. The profits from this venture led to their becoming one of the biggest game companies in Asia.

Colossal Cave Adventure
1976

TEXT ADVENTURE

PDP-10

Colossal Cave Adventure is the first known work of interactive fiction, a medium primarily composed of text. Players type actions into a text parser, which interprets the input and responds by either rejecting the command or moving the story forward.

Colossal Cave Adventure is also the first example of a text adventure, the precursor to adventure games. In the game, players input directions and commands to guide their character through a sprawling cave system filled with riches. Designer Will Crowther and his then wife Patricia were avid cavers, and they folded their knowledge of Kentucky's Mammoth Cave system into the game's design.

One of Crowther's inspirations for *Colossal Cave Adventure* was his desire to forge a deeper connection with his daughters after his divorce from their mother. The game also combined his fondness of role-playing, such as in games like *Dungeons*

& Dragons, with his fondness of caving in a simple, engaging format. According to Crowther, his daughters loved the game. Its simplicity and sense of mystery intrigued players for generations, leading to the inclusion of mechanics like mysterious room structure, inventory systems, noneuclidean mazes, and more as staples of the text adventures, role-playing games (RPGs), and roguelikes that came later.

Inputting the magic word "Xyzzy" allowed the player to teleport between two locations in the game. Many other computer programs followed suit by including little Easter eggs for people who inputted "Xyzzy." The game also returned the message "Nothing happens" when players entered the code in the wrong location.

Zork
1977

TEXT ADVENTURE

PDP-10 COMPUTER

Zork followed shortly after *Colossal Cave Adventure*, expanding on that game's design with a more intelligent, sophisticated text-parsing system. Named for a nonsense word that programmers used to refer to unfinished programs, *Zork* was originally intended to be called "Dungeon" until Tactical Studies Rules, the publisher of *Dungeons & Dragons*, claimed that it violated their copyright.

The game was programmed on the common computer system of the time, the PDP-10 (an earlier version of which was used to program *Spacewar!*), which was too big and expensive for home use. Because of this, *Zork*, like many early games, was designed without copyright or sales restrictions, and the game's developers, Dave Lebling, Marc Blank, and Tim Anderson, built it without thinking that others would be able to play it.

However, the simplicity of porting (transporting an existing game to a different system than the one it was developed for) text adventures meant that eventually they were able to create other versions, including versions for the personal computer, through Infocom. The game was later split into three parts and redesigned for cohesion. Between 1980 and 1982, editions were released for the Atari 8-Bit, Commodore 64, and other systems under the names *Zork I: The Great Underground Empire*, *Zork II: The Wizard of Frobozz*, and *Zork III: The Dungeon Master*.

❖ ❖ ❖

Space Invaders
1978

 SHOOTER **ARCADE**

Space Invaders remains a popular game in arcades today, with its simple yet addictive gameplay and pop culture fame. It's commonly used as a symbol of the past in movies such as *Terminator 2: Judgment Day* and TV shows like *Robot Chicken,* with its iconic spaceships and blooping soundtrack being synonymous with classic video games.

The game's straightforward combat and alien enemies inspired legions of shooters to come. Designer Tomohiro Nishikado created all the hardware and software from the ground up, as the technology that existed at the time was insufficient to power his vision of a game in which players shoot at aliens (he believed that it was immoral to depict violence against humans). Though Nishikado cited Atari's *Breakout* as his biggest inspiration, he was reportedly also influenced by a dream he had in which Japanese school-children waiting for Santa Claus were attacked by aliens.

Space Invaders was distributed by the company Taito in Japan, where it rapidly grew in popularity until even regular stores began replacing their wares with arcade cabinets. Taito licensed the game to Atari for home use—the first such deal—and it was released for the Atari VCS shortly after the films *Close Encounters of the Third Kind* and *Star Wars* hit theaters, tapping into America's growing interest in aliens.

The timing paid off. *Space Invaders* became the first "console killer app"—a term for games that encouraged people to buy a console, in this case the Atari VCS. Four years after its release, the game had grossed $3.8 billion—some $13 billion today after adjusting for inflation—making it the highest-grossing video game until *Pac-Man* dethroned it in 1980.

The cabinet of the arcade version of *Space Invaders* depicts humanoid monsters rather than the bug-like aliens portrayed in the original game. Tomohiro Nishikado believed this was because the cabinet artist based the designs on the original title, "Space Monsters," instead of on the game's art.

MUD
1978

 MULTI-USER DUNGEON

 PDP-10

Before we had massively multiplayer online role-playing games (MMORPGs)—giant, shared worlds in which many players could play together—we had MUDs. The acronym, short for "multi-user dungeon," also refers to *MUD*, a 1978 game by Roy Trubshaw and Richard Bartle. Inspired by the "Dungeon" version of *Zork* as well as by *Dungeons & Dragons*, Trubshaw and Bartle wrote and designed the game to be a virtual world in which multiple players could play together. Like many other role-playing games of the era, *MUD* was text-based, but rather than playing solo, players connected over ARPANET, a precursor to today's internet, and interacted through a text parser that responded to simple commands.

Given the limited technology of the time, *MUD* was an impressive feat. However, only a few people had access to ARPANET, which limited the appeal of MUDs and made it

difficult for the genre to grow. Still, designers through the '70s, '80s, and '90s continued to create MUDs, adding complexity and new features as the infrastructure improved. Though text-based interfaces were no longer the norm as games started to move in a more realistic and graphics-heavy direction, the expansion of the MUD genre helped lay the groundwork for the MMORPGs, such as *World of Warcraft* and *EverQuest*, that would come later.

❖ ❖ ❖

ENTER?

>_

Asteroids
1979

 SHOOTER **ARCADE**

Asteroids, like *Spacewar!* and *Space Invaders*, is a space-themed shooter in which players control a spaceship and attempt to destroy enemies. Specifically, players shoot at enemy spacecraft and asteroids to clear the starfield of debris. The targets break into smaller pieces as they're shot, providing more obstacles and thus complexity. As with many games of the era, there's no win state. Players continue until they run out of lives or until they reach the top score of 99,990, at which point the machine "turns over" and resets the score back to zero.

A little-known fact is that the game's two nameless flying saucers that chase the player around when they get close to clearing the field were originally referred to as Mr. Bill and Sluggo, named after two characters on *Saturday Night Live*. When designer Ed Logg mentioned their names in an interview with *Esquire*, NBC's lawyers sent Atari a cease

and desist letter, forcing Atari to stop referring to the ships by those names.

Atari had originally intended for *Lunar Lander* to be its next hit game, but *Asteroids* ended up being more popular, which resulted in many *Lunar Lander* cabinets being outfitted with *Asteroids* instead. Although *Space Invaders* remains one of the highest-grossing video games of all time, in part thanks to its numerous console ports, *Asteroids* grew so popular that it gave that game some strong competition. In fact, to keep up with the game's intense popularity, many arcade operators installed larger cash boxes in *Asteroids* cabinets to allow the game to run for longer without needing to be emptied.

Adventure
1979

 ADVENTURE **ATARI 2600**

Developed as a graphical take on *Colossal Cave Adventure*, Warren Robinett's *Adventure* is one of the earliest examples of an adventure game. It introduced a visual representation of an explorable labyrinth that encouraged players to discover its secrets without having to rely on their imaginations or on maps they drew themselves, as was the case with earlier text adventures.

One of those secrets is the game's hidden "Easter egg." At the time, Atari didn't allow designers to include credits in their work; they wanted to prevent other companies from luring talented workers away with better job offers. Inspired by the secrets hidden on the Beatles' *White Album*, Robinett included his own name in the game, discoverable by following a series of hidden actions. Though often credited with being the first to do so, Robinett was only one of many designers seeking recognition for their work. In 2017, it was

discovered that a 1977 game called *Starship 1* also held a hidden message, and that 1978's *Video Whizball* contained a secret credit.

Adventure's Easter egg was discovered by a fifteen-year-old boy, and the feature made the game so popular that Steve Wright, manager of Atari's home video game department, made it official policy that all the company's games should contain Easter eggs from that point on.

Finding *Adventure*'s Easter egg was difficult. Players had to locate a single gray pixel embedded in a gray wall, and transport that pixel—which became invisible if dropped anywhere other than in a catacombs passage—to another area of the game. When carried to the correct place, the pixel caused one of the walls to flash, allowing the player to step through it. The successful player was then treated to a color-changing credit line that read, "Created by Warren Robinett."

Missile Command
1980

 SHOOTER ARCADE

Missile Command stands apart from many arcade games. Not only was it the first Atari game to be in color, but it was also one of the earliest examples of narrative, particularly player-driven narrative. Developed around the concept of a radar screen, *Missile Command* tasks players with protecting six cities from incoming missile attacks. Designer David Theurer, wanting to avoid the aggressive nationalism that might follow a nuclear weapon–themed game during the Cold War, deliberately did not name the cities being defended or the aggressor, and he advocated for the player to take a purely defensive role.

Instead of shooting enemy ships, players had to make quick decisions about which bases they would save and which they would sacrifice by deploying missiles to eliminate the enemy's attacks. The result, as Theurer had hoped, was a tense game that had the potential to make players think

more deeply about war rather than encouraging xenophobia. Theurer's devotion to the project gave him intense, graphic nightmares about nuclear war occurring on the California coast. His attempt to create a game that would leave a legacy was successful, as both its message and its exciting gameplay made impressions on a generation of players.

Pac-Man
1980

 MAZE **ARCADE**

Pac-Man is one of the most recognizable video games of all time. In the 1980s, most games were space- or sports-themed, and *Pac-Man* attempted something totally new. Players had to avoid several ghosts as they navigated a maze, advancing when they collected all the Pac-Dots. Designer Toru Iwatani is said to have created the game with a new, less aggressive style of gameplay, as well as cute ghost characters, to encourage more women to come to arcades. It worked; not only did *Pac-Man* have a higher number of female players, but it became a smash hit, selling over 100,000 arcade cabinets, appearing on the cover of *Time* magazine, and even getting its own cartoon TV series.

It seemed a natural next step to create a home-console version of Pac-Man, but the edition developed for the Atari 2600, which came out in 1982, was significantly different from the arcade version. It contained numerous errors, and

though it became the best-selling game for the system, its poor quality eroded confidence in the Atari brand. In hopes of better sales, Atari overproduced *Pac-Man* cartridges, which left the company with some five million unsold games, a key factor in the video game crash of 1983.

Billy Mitchell was believed to be the first person to reach a perfect score on *Pac-Man* of 3,333,360 points. However, Mitchell's scores were wiped from Twin Galaxies, a video game-ranking database, after accusations that he achieved his record-breaking *Donkey Kong* scores using an emulator rather than arcade hardware. Seven other players have since reached the maximum score—and have also beat Mitchell's time by several hours.

Ultima
1980

RPG **APPLE II**

Richard Garriott's *Ultima* wasn't necessarily the first role-playing game, but its inventive features and polish made it the standard by which all later RPGs would be judged. Created as a follow-up to *Akalabeth*, which Garriott had produced as a hobby project in 1979, *Ultima* offered innovative takes on the genre, including character creation, a strong narrative, an open world, side quests, and, in the sequels, a developed morality system comprising virtues that needed to be balanced.

As a member of the Society for Creative Anachronism, Garriott had an interest in role-playing and in Renaissance Faires that no doubt influenced his choice to develop the game as a medieval fantasy. That setting, which was fairly unique for video games at the time, was just one part of the game's appeal. Garriott also intentionally courted devoted gamers with advanced features ranging from in-game

music to beautiful packaging that included "feelies" like maps and coins.

The popular *Ultima* series was originally published by Sierra On-Line; however, after a falling out with Garriott, the two separated. Shortly after the split, Sierra On-Line published a sequel without Garriott's input and, to make sure he got the message, included enemies with names that sounded similar to his. In response, Garriott formed his own company, Origin Systems, and published thirteen more core *Ultima* games, some of which are the most beloved in the franchise.

Sierra On-Line manufactured only about three thousand copies of the sequel, *Ultima: Escape from Mt. Drash*—the bare minimum needed to satisfy its contract. Though made with Garriott's permission, the game was produced without his oversight, and Sierra didn't have faith it would sell. In fact, the company denied its existence until the game's writer, Keith Zabalaoui, confirmed that it had shipped. Since then, it's become a collector's item, with only a few cartridges known to remain in existence.

Rogue
1980

DUNGEON CRAWLER

PDP-11, VAX 11

Today, 1980's *Rogue* may not look like much, but designers Michael Toy and Glenn Wichman invented an entire new genre with their ASCII-art creation, which blended the fun of fantasy games like *Zork* and *Adventure* with the thrill of permanent death and procedural generation. *Rogue*'s innovations coined "roguelikes": games that are different each time you play them, and in which death ends your current run and forces you to start over.

The idea of procedural generation wasn't completely new at the time; 1978's *Maze Race* and *Beneath Apple Manor* both featured algorithmic design that created new levels each play through. Toy and Wichman aimed to use procedural generation to keep fantasy gaming, like the kind they enjoyed in *Zork*, feeling fresh and exciting. Instead of solving the same puzzles over and over, you could encounter new enemies and dungeon designs every time you played.

Rogue was immensely popular on college campuses because it was distributed first among University of California schools and was later included as part of Berkeley Software Distribution 4.2, an operating system shared throughout ARPANET. However, it struggled to find a foothold once Toy and other developers tried to create a commercial version. Still, its popularity inspired other developers to incorporate elements from the game's initial design by adjusting the original code or creating new versions from scratch. Today, roguelikes are an incredibly popular genre, and even AAA games—games produced by large or midsized publishers, as opposed to those developed independently—are often modified or played with "permadeath" rules to enhance the thrill.

In 1981, four grad students at Carnegie-Mellon University wrote a program, called Rog-O-Matic, that could play and win *Rogue* on its own. In every subsequent release of *Rogue*, Ken Arnold, who contributed to the game late in its development, included a feature that would break Rog-O-Matic.

Donkey Kong
1981

 PLATFORMER **ARCADE**

Donkey Kong was the game that introduced the world to the platformer genre. It also was the first Nintendo game to successfully break into the North American video game market, and it marked the start of video game luminary Shigeru Miyamoto's illustrious career.

 Donkey Kong included innovative elements like story-advancing cutscenes and, of course, Nintendo's iconic mascot, Jumpman. As Jumpman, the player hopped over barrels and flames to rescue his pink-clad girlfriend, Lady, from the threatening gorilla, Donkey Kong.

 Though the name *Donkey Kong* is now ubiquitous, it was originally a point of contention for the Japanese company and its American counterpart. Miyamoto named the game by consulting an English dictionary, which suggested "donkey" as a synonym for "stubborn" and "Kong" as a substitute for "gorilla." Executives at Nintendo of America laughed at

the name choice, probably because, despite "Kong" being a clear reference to King Kong, the addition of "donkey" meant little. Regardless, the name stuck.

In addition to being perplexed by the unconventional name, Nintendo of America was also concerned by the gameplay, which was completely different from the standard of the day. Still, at the insistence of Nintendo of America's president, Minoru Arakawa, they adapted it for American audiences. The risk paid off—thanks to the game's exciting new mechanics. The company sold some sixty thousand arcade cabinets, as well as licensing deals with Coleco, Atari, and Intellivision.

Unfortunately, a lawsuit with Universal, who claimed they owned the rights to the name *Donkey Kong*, caused many of the licensing deals to collapse, even after a court case showed that the lawsuit was baseless.

Jumpman and Lady, *Donkey Kong*'s central characters, are Nintendo icons. Lady is the earliest example of a female character in a video game with a speaking role. In the American release, Lady was renamed Pauline, and Jumpman to Mario, after the landlord of the Nintendo of America warehouse.

Castle Wolfenstein
1981

 SHOOTER **APPLE II**

Castle Wolfenstein isn't just the first game in an iconic series—it's also arguably the first game in the stealth genre. With the early introduction of innovative elements like in-game speech, a reduced and set amount of ammunition, and an atmospheric sense of dread and fear, *Castle Wolfenstein* set an early precedent for what stealth games could and should be.

The player, as an Allied prisoner during World War II, was tasked with stealing secret plans from a Nazi-controlled castle, and could hide from, impersonate, and kill Nazi soldiers to accomplish the mission. However, because ammunition was limited, the player was forced to strategize and think creatively. Muse, the game's developer, was an early adopter of voice technology, so *Castle Wolfenstein*'s enemies were able to say short phrases like "Halt!" at a time when in-game voices were nearly unheard of. Though it took almost a

decade after *Castle Wolfenstein*'s release for the stealth genre to grow to prominence, it was these mechanics that would pave the way and ultimately become staples of the genre.

> *Castle Wolfenstein* was one of the first games to inspire an "art mod," a type of fan-made programming that is often designed to subvert the original game in some fashion. In the case of *Castle Wolfenstein*, the 1983 mod *Castle Smurfenstein* replaced all the Nazis in the game with Smurfs.

Galaga
1981

 SHOOTER **ARCADE**

One of the most successful games from the golden age of arcade games was essentially an improved version of *Space Invaders* and its own direct predecessor, *Galaxian*. That's not to say *Galaga* wasn't original—in fact, its mechanics and construction literally changed the industry—but that it's a perfect example of the video game industry's tendency to build on the foundations of previous games in order to release complex games at a rapid pace.

The biggest improvement *Galaga* made on *Space Invaders* was the introduction of the ship-stealing Boss Galaga, which would capture one of the player's ships and force them to focus their efforts on getting it back. Because the controls were so complex, the cabinet was designed with a first-of-its-kind horizontally mounted joystick and buttons. The horizontal mount was so effective that it quickly became the standard for all other cabinets and likely influenced

controller design as well—which was another way *Galaga* improved and influenced the rest of the industry.

Early tests of the game showed that turns lasted far longer than they did in other arcade games—some for seven to eight minutes rather than the standard four. However, when asked to modify the turn time, creator Shigeru Yokoyama stood firm in his opinion that the extended playing time would benefit the game in the long run. Sure enough, *Galaga* became a hugely influential and popular game for years, in part because the unusual turn length gave players even more time to fall in love with its gameplay.

E.T. the Extra-Terrestrial
1982

 ADVENTURE **ATARI 2600**

Atari's tie-in game *E.T. the Extra-Terrestrial* was meant to bring the blockbuster success of Steven Spielberg's hit film to the gaming world. Steven Ross, head of Warner Communications, promised the director some $25 million for the license in July 1982, and assured Spielberg that the game would be on store shelves by Christmas. This gave designer Howard Scott Warshaw only around six weeks to put the game together. Despite disagreeing with Spielberg on the concept, Warshaw pushed ahead with his own design and created a game in which players, as E.T., collected telephone pieces to call back their ship.

By 1982, video game companies were saturating the market with games because more people owned consoles. However, following the notoriously bad Atari 2600 version of *Pac-Man*, customers grew more discerning about what games they purchased. When *E.T.* was released, enough good

games were on the market that fewer people felt compelled to rush out and buy a game just because it was new. With so little time for development and no marketing to support it, *E.T.* seemed fated to fail. The game was both frustrating and difficult, and as news of its poor quality spread, few people bought it, making it a critical and commercial failure.

Almost all the five million copies produced were sent back to Atari. According to an urban legend, Atari attempted to dispose of the cartridges by burying them in a New Mexico landfill, steamrolling and pouring cement over them to hide their existence. In 2014, the crew behind the documentary film *Atari: Game Over* discovered the roughly 700,000 games Atari had buried. *E.T.*'s disastrous release is considered a contributing factor to the video game crash of 1983.

Ms. Pac-Man
1982

 MAZE ARCADE

Ms. Pac-Man designers Doug Macrae and Kevin Curran weren't working on an official sequel when they came up with this iconic game. At the time, both Macrae and Curran were known for building enhancement kits that could be added to existing game boards to change gameplay—such as making *Missile Command* faster.

After *Missile Command*, they set their sights on a *Pac-Man* enhancement they called *Crazy Otto*. However, a lawsuit and subsequent settlement with Atari over their *Missile Command* enhancement board locked them into a deal that allowed them to continue making games provided that they didn't create any more enhancement boards without the license holder's permission. Driven to continue their work, Macrae and Curran met with Midway, the American distributor for *Pac-Man* (but not the license holder—that was Namco, which had been dragging its heels on producing a sequel

to the hit game). Midway gave them permission to create a full sequel rather than just an enhancement board.

The game they built for Midway, instead of a true sequel, was ultimately just *Pac-Man* with an enhancement kit. The base game was the same, with randomness added to increase the difficulty so that players could not memorize and exploit the patterns of the ghosts, as they did for *Pac-Man*.

Still, despite its being an enhancement kit and not an entirely new game, Midway approved *Ms. Pac-Man* after instituting a series of last-minute changes and finding the right name (from *Crazy Otto*, it went through a series of variations). Over 115,000 machines were sold, more than the original *Pac-Man*, and Namco eventually adopted it as an official sequel to the iconic game with a 1985 Famicom port.

The conflicting reports over whether *Ms. Pac-Man* was produced with or without Namco's permission were only a hint of what was to come. Following several other unauthorized sequels to *Pac-Man*, Namco and Midway terminated their licensing agreement in the early 1980s.

Pitfall!
1982

 PLATFORMER **ATARI 2600**

Side-scrolling platformers are one of the most iconic genres in video games. *Sonic the Hedgehog* and *Super Mario Bros.*, for example, are two incredibly important cultural touchstones for the medium, but neither game is the genre's originator. That honor belongs to 1982's *Pitfall!*, which, while less celebrated than some other platformers, essentially invented the side-scrolling genre.

The concept for the game, created in about ten minutes by designer David Crane, was simple: he drew a man running, then a place for the man to be, then a reason to be running, and that was that. Players, as the character Pitfall Harry, have twenty minutes to run through the jungle, swing over obstacles, and collect treasures while avoiding enemies like rattlesnakes and crocodiles. Though simple in execution, the game was incredibly addictive—the Atari 2600 version was a best-seller in 1982.

Whether or not it was intentional, many of *Pitfall!*'s core features would become wildly influential in later games. Elements like running and jumping defined the *Mario* series, while collecting treasures and avoiding obstacles were core parts of *Tomb Raider*. Even if it's less famous than other titles, *Pitfall!* was a major influence on the platformer genre as we know it today.

Though David Crane claims that the game took just a few minutes to design, programming it required about a thousand hours. Hardware limitations meant that Crane had to be creative, including reusing small sprites to produce the image of the game's swinging vines.

THE VIDEO GAME CRASH OF 1983

It's almost hard to believe that one year would make the difference between the booming video game industry of 1982 and the disastrous events and uncertainty many people had about the future of video games in 1983.

The gaming industry's rapid growth until 1982 yielded many unintended and unforeseen consequences. As companies like Atari consistently raked in millions of dollars in console and video game sales, other companies decided that they wanted to get their slice of the pie, too. One of the many companies to jump into the fray was Activision, founded by former Atari workers. Activision was among the first to try to produce games for Atari consoles despite the company's attempts to block them in court. Unfortunately, Atari failed to get a restraining order and had to settle. This chain of events suggested to other third-party developers that the time was right to start producing games of their own. The result was around one hundred companies, including Quaker Oats, flooding the market with new video games in 1983.

More companies meant more games; however, many were of very low quality, which eroded consumers' faith

and goodwill toward the industry. Even established video game companies weren't exempt from making their fair share of poor-quality games. Atari's notorious *E.T. the Extraterrestrial* and the Atari port of *Pac-Man* are only two of countless examples. There were simply too many games on the shelves, and many consumers were becoming more discerning purchasers. Customers also realized that personal computers had more gaming viability than consoles, and sales of both games and consoles dropped by 97 percent between 1983 and 1985. Analysts began to question whether video games had a future.

This difficult relationship between the games and buyers, plus the overall downward trend across the industry, meant that stores were reluctant to carry video games. When stores tried to send unsold games back to manufacturers, the manufacturers had no money to reimburse them—just more new games to push. New games ended up in bargain bins for five dollars or, in the case of *E.T.*, *Centipede*, and *Star Raiders*, got buried in landfills. Unfortunately, arcades weren't safe either. With more people playing games at home, around fifteen hundred arcades closed in the mid-'80s, and overall arcade revenue fell by 40 percent.

Things were looking dire, and a complex, devastating cycle ensued. Game companies were hemorrhaging

money, and retailers largely stopped carrying consoles. Without consoles, people didn't buy games, and if people weren't buying games, the market was going to die.

Then Nintendo came along with the Western version of its hit Famicom console. Seeing the direction the US games industry was headed, Nintendo made some fundamental changes to its marketing strategy. The new device, the Nintendo Entertainment System (known as NES), intentionally avoided familiar video game language and design. Even its name was meant to suggest that it was more of a toy than other console systems.

Nintendo also limited the number of third-party games that could be released on the system per year, and stamped all the approved games with a "Seal of Approval." Consumers could trust that the games marked with the symbol were of high quality because Nintendo itself had certified them. Gradually, the industry began to recover, and in 1986, the year following the release of NES, it began to see the first signs of growth since 1982.

Dragon's Lair
1983

ADVENTURE **ARCADE**

Fully animated, with film-quality graphics in a style that wouldn't become standard for years to come, *Dragon's Lair* looks completely different from every other game of the era. Publisher Cinematronics was able to achieve this groundbreaking graphical standard thanks to a combination of LaserDisc technology and art by former Disney animator Don Bluth. At the time, Bluth was known for directing the movie *The Secret of NIMH*, which used labor-intensive but traditional techniques like rotoscoping and backlighting to achieve its smooth, lifelike animation.

Of course, the additional technology needed to create the game was expensive, a cost that was transferred to the player, and *Dragon's Lair* became the first arcade game to cost fifty cents per play.

Though the LaserDisc was perfect for the advanced graphics, gameplay was limited to simple binary choices—

choose wrong, and your character died. Players would watch a short animated cutscene, then make a quick decision about what the hero, Dirk the Daring, would do. He might dodge left or right when presented with one of numerous obstacles on his quest to rescue the beautiful Princess Daphne from the clutches of a dragon, but there was only one correct choice, leading players to memorize the path to success. Though it was incredibly successful at first, the game lacked longevity because of its linearity despite the appealing animation. Players just had no interest in sinking their quarters into a game they'd already beaten and couldn't get better at.

Dragon's Lair was a huge success for a while during the early '80s despite the waning popularity of video games, but public perception soured as the limitations of the hardware began to appear—LaserDisc games suffered hang-ups as they transitioned between scenes, and the machines broke down frequently. Still, the beautiful graphics and innovative technology set the stage for the industry's future when such features would become standard.

Because Cinematronics lacked the money to hire live models, Bluth instead used photos from *Playboy* magazines as inspiration for the game's damsel in distress.

Tetris
1984

 PUZZLE **ELECTRONIKA 60**

Tetris is one of the most recognizable and well-known video games, but it also has possibly the most convoluted history. Designed by Alexey Pajitnov, an employee of the Computer Center of the Moscow Academy of Science, this simple puzzle game consists of variously shaped four-squared blocks dropping from the top of the screen. Players move the blocks into positions, clearing the screen one line at a time by filling each row with blocks. Because all business was owned by the government of the Soviet Union, Pajitnov's game didn't technically belong to him—though it was catchy, he couldn't sell it.

Then in 1986 a friend of Pajitnov sent the game to the Institute of Computer Science in Budapest, where Robert Stein played it. He sought the license, but Pajitnov didn't have the authority to grant it. Regardless, Stein sold rights he didn't have to two different companies, including Spectrum

HoloByte, which in turn sold to Atari, which in turn sold to Sega and Henk Rogers, a Dutch game publisher.

Rogers later flew to Moscow to negotiate further, and Elektronorgtechnica, a state organization that controlled computer hardware and software imports and exports in the Soviet Union, offered him worldwide rights, which he extended to Nintendo. Both Tengen, a subsidiary of Atari, and Nintendo released their games within a month of one another. Tengen's version was arguably the better one. However, when Atari filed a copyright claim against Nintendo shortly after the 1989 release, Nintendo won because it had a stronger claim on the rights thanks to Rogers's legitimate negotiations with Elektronorgtechnica. Nintendo forced Atari to recall its cartridges and ultimately sold over forty-three million copies of *Tetris* for the NES and Game Boy alone.

Throughout this fervor, Pajitnov made no royalties because he didn't own the rights. It wasn't until 1996, when Elektronorgtechnica's rights expired, that the game's rights finally reverted back to Pajitnov. He and Rogers set up Tetris Company, LLC. Finally, after more than a decade since the game's release, Pajitnov was able to earn royalties from his creation.

King's Quest:
Quest for the Crown
1984

 ADVENTURE **IBM PCJR**

Sierra On-Line is practically synonymous with the adventure game genre, and *King's Quest* is largely why. It was the first adventure game to use on-screen animation rather than just text input and static scenery, and it incorporated a navigable environment, a sense of humor, and notoriously difficult puzzles, which were designed by Roberta Williams.

Players control the knight Sir Grahame on his quest to find three legendary treasures by solving puzzles. The combination of story, animated graphics, and tricky puzzles set the game apart from many other adventure games, but it was slow to attract attention.

King's Quest was originally developed for IBM's PCjr, a home computer that was poorly received by the public. As a result, the game floundered. It wasn't until ports to the IBM PC and Tandy 1000 were developed that the game's

momentum picked up and the franchise took off, influencing every graphic adventure game to follow.

King's Quest designer Roberta Williams is frequently considered not just one of the most influential game designers in history, but also the creator of the graphic adventure genre. *King's Quest* and other graphic adventures are the basis for such diverse genres as visual novels, walking simulators, and all kinds of other adventure games, including *Myst*, *The Secret of Monkey Island*, and even more recent games like *The Talos Principle* and *Night in the Woods*.

Super Mario Bros.
1985

 PLATFORMER **FAMICOM/ NES**

Long regarded as one of the most important and influential games of all time, Nintendo's *Super Mario Bros.* is celebrated in part because of its refined simplicity. Its mechanics—primarily running and jumping—are introduced through gameplay rather than an extensive tutorial, and by the end of the first level the player has every bit of knowledge they need to succeed.

The player controls Mario as he runs, jumps, and shoots fireballs at a variety of enemies in thirty-two different stages, following the trail of Princess Toadstool, who has been kidnapped by King Koopa.

Super Mario Bros. was a pioneer in multiple areas, including the then remarkable use of Koji Kondo's soundtrack to affect players' emotions in a film-like fashion. Behind the scenes, the development team was one of the earliest examples of specialization in the industry—people would work on

only certain aspects of the game, rather than everybody having a hand in everything.

Following its worldwide release in 1985, *Super Mario Bros.* sold over forty million copies, becoming one of the best-selling games of all time and helping to restore interest in video games after the crash of 1983.

In 1990, a Q Score study suggested that Mario was more recognizable among children than even Mickey Mouse, cementing Nintendo's place in both video games and global pop culture.

The Oregon Trail
1985

 ADVENTURE **APPLE II**

In the early days, video games were generally considered entertainment for adults. Surprisingly, arcade machines were typically found in bars before there were all-ages-friendly arcades. In fact, Nolan Bushnell's pivot from founding Atari to founding Chuck E. Cheese was in part intended to bring video games to a younger audience. Don Rawitsch, Bill Heinemann, and Paul Dillenberger, designers of *The Oregon Trail*, which first came out in 1971, had a similar mission: to teach children about history through play.

The original, educational version of the game was popular, especially with the Minnesota school system, but it wasn't intended for commercial purposes. It wasn't until the release, with help from Rawitsch, of the Minnesota Educational Computing Consortium (MECC) version, which added computer graphics, that *The Oregon Trail* received mainstream attention. Interestingly, the home version was actually *more*

historically accurate than the version developed for education, because it used real probabilities for random events like storms and wagons breaking, time-period-appropriate music, and accurate locations.

Despite its educational roots, *The Oregon Trail* was a huge commercial success. Over its ten iterations, it has sold over sixty-five million copies. It's easily one of the most successful "edutainment" games in the industry's history, reminding players and designers that games can be fun as well as great for learning.

Castlevania
1986

 ACTION FAMICOM/ NES

We might laugh now to think that *Castlevania* was considered more realistic and serious than many games of its time, but that was what made it so unique. Players were intrigued by its dark atmosphere, and the intense story of Simon Belmont venturing into the dark, dreary castle of Count Dracula to slay the famed vampire was in stark contrast to the humor of *King's Quest* and the levity of *Super Mario Bros*. The gameplay was deliberately limited and sluggish, making the player feel vulnerable and amplifying the story's horror-filled atmosphere. Later, these features would become standards in the horror genre, appearing in games like *Alone in the Dark* and *Resident Evil*, which put even more emphasis on making the player feel afraid.

Released in Japan as *Akumajō Dracula*, which translates roughly to "Demon Castle Dracula," the name was changed for American audiences because executives at Konami of

America believed that the translation was "Satanic Castle." Since the game was scheduled to be released during the height of the Satanic Panic, such a connotation could have tanked its potential success, particularly with parents. Hence the name change to *Castlevania*—a portmanteau of "castle" and "Transylvania," the game's setting.

Though generally well received and commercially successful, the first game in the series was largely overshadowed in critical success by its sequel, *Castlevania: Symphony of the Night*, which is considered by many to be one of the best video games of all time.

> The US release of *Castlevania* on May 26, 1987, was timed to coincide with the ninetieth anniversary of the release of Bram Stoker's novel *Dracula*.

The Legend of Zelda
1986

ACTION-ADVENTURE

FAMICOM/NES

Though *The Legend of Zelda* was developed alongside *Super Mario Bros.*, there couldn't have been two games that were more different in tone, mechanics, and complexity. Under the watchful eye of Shigeru Miyamoto, who was behind the success of *Donkey Kong*, the game felt and looked completely different from anything else on the market. Miyamoto was even concerned that the game would fail because it asked players to think about strategy more than any other game made so far. He believed that the level of forethought required might bore or stress those who were unaccustomed to this more complex style of play.

Blending the mechanics from action, adventure, and role-playing games, *Zelda* allowed players to navigate and explore a largely open world on their quest to rescue Zelda from the evil Prince of Darkness Ganon, instead of progressing in a more straightforward, linear fashion. While

the game wasn't the first in any of those three genres to use these mechanics and elements, what made it unique was how it combined and adapted the existing genres with its open world and nonlinear narrative.

It was also quite a bit larger than most other games. *The Legend of Zelda* was the first game to include an internal battery in the cartridge, which allowed players to save their game and then return to it later. It also included a great deal of information in the manual and even a phone number people could call for help, which was introduced because Minoru Arakawa, founder and former president of Nintendo of America, was concerned that the text and complexity of the game would put off American players. Despite everyone's fears and concerns, American players responded positively to the game, though it did take some time for them to warm up to it, and *Zelda* sold over six million copies worldwide following its initial Japanese release in 1986.

> The Legend of Zelda was designed to let the player experience the fun of a wide, explorable virtual world. Inspired by his childhood love of hiking and exploring nature, Miyamoto created the game to capture the feeling of seeking adventure in the natural world.

Metroid
1986

ACTION-ADVENTURE

FAMICOM/NES

By 1986, Nintendo had established itself as a company of innovation and quality. With games like *Super Mario Bros.*, *The Legend of Zelda*, and *Donkey Kong* under its belt, the company looked to continue its streak with *Metroid*, an action-adventure game with a nonlinear structure, an early level-up system, and one of the industry's original female protagonists.

Inspired by the 1979 film *Alien*, the team behind *Metroid*, including Gunpei Yokoi, Satoru Okada, and Masao Yamamoto, created something that filled the player with dread by drawing inspiration from science fiction horror films. The world of *Metroid* was dark and packed with threatening aliens, unlike the cheerful worlds of *Mario* and *Zelda*.

The horror video game genre was in its infancy, so *Metroid* was still an unusual approach for an industry that, so far, had been primarily about making the player feel powerful.

For example, instead of starting with an arsenal of potent weapons, the player, as Samus, has to collect items that will permanently make her stronger as she fights H. R. Geiger–inspired aliens on her quest to destroy Mother Brain.

Metroid was also one of the first games to feature multiple endings. Which ending players received depended on how long they took to complete the game. It wasn't until players unlocked the third, fourth, and fifth endings that Samus was revealed to be a woman without her power suit.

Samus was one of the industry's first playable female protagonists, but many players never knew it. The English-language game manual referred to Samus as "he," and players had to beat the game in under five hours to see Samus without her power suit. Beating the game in three to five hours featured an ending in which she removed the helmet to her power suit, revealing her long hair. By beating it in under three hours or entering the code "JUSTIN BAILEY" in the Western releases of the game, players would see her in a sort of leotard, and beating the game in under an hour would reveal Samus in a bikini.

Dragon Quest
1986

 RPG FAMICOM/ NES

By 1986, the role-playing-game genre had been well established thanks to games like *Wizardry* and *Ultima*, but then *Dragon Quest* came along and shook things up. Designer Yuji Horii aimed to bring RPGs to the masses by simplifying the sometimes opaque design of earlier games in the genre. He did away with the references to *Dungeons & Dragons* and helped players connect with a hero they'd want to play and level up over time.

To make the genre more approachable, Horii designed *Dragon Quest* so that players would level up more frequently at the beginning of the game, which is now a standard feature in many modern RPGs. Likewise, *Dragon Quest* offered an open world that was truly nonlinear, meaning that players could explore the world at will, but they ran the risk of running into monsters that could easily kill them if they hadn't leveled up enough. By opening the game up

and encouraging players to explore, the design allowed people with less video game experience to learn by doing, rather than by already knowing.

Though sales were initially slow (the game's publisher, Enix, actually believed that it would lose money), *Dragon Quest* eventually caught on and became incredibly popular in Japan, where it sold some two million copies. Unfortunately, the American version, released as *Dragon Warrior,* was considered a commercial failure, but it still contributed to the eventual popularization of the RPG genre.

Though American players weren't interested in buying *Dragon Quest*, that didn't mean they weren't playing it. New subscribers to *Nintendo Power* magazine received a free copy of the game in 1990, reportedly to make use of the unsold copies after its release flopped. Even today, the *Dragon Quest* franchise struggles to gain a foothold in the Western market, though it's incredibly successful in Japan, selling millions of copies and even being featured in a ride at Universal Studios Japan.

Final Fantasy
1987

 RPG **NINTENDO ENTERTAINMENT SYSTEM (NES)**

With a core team of just seven people, Hironobo Sakaguchi created *Final Fantasy*, a game that he thought would be his last, unaware that it would become arguably the most famous RPG series in video game history. The game follows four Light Warriors as they seek to defeat evil and return the light to the orbs they carry, saving the world from darkness.

Executives at Square had long resisted Sakaguchi's desire to make an RPG until they saw the success of *Dragon Quest*. With Square struggling to stay afloat, Sakaguchi and Kenji Terada were finally allowed to create their game. *Final Fantasy* combined aspects of earlier RPGs like *Ultima* and *Wizardry* with innovative features, such as showing the character's sprite on-screen alongside the enemy, and a rich and developed story. It was even influenced by American football and Formula 1 racing.

The game was a smash hit, selling 520,000 copies in Japan alone, which was more than the 400,000 copies Sakaguchi needed to earn a sequel. Ironically, the game's financial success not only saved Square but completely redefined what the publisher was known for from then on. Though it wouldn't be until *Final Fantasy VII* was released ten years later that the series gained a foothold in America, the original game became an inspiration and set the standard for generations of RPGs to follow.

The game's title, which seems ironic after the release of well over a dozen games in the main series alone, has long been the subject of urban legend. According to one story, the title refers to Sakaguchi's sense that the game would be his last. While partially true, this version of events doesn't cover everything. Even before a title was chosen, the team sought a name that could be abbreviated to "FF"—something that is both easy to write in Latin script and produces a pleasant, four-syllable sound in Japanese ("efu efu"). "Final" was actually a second choice; it was meant to be titled "Fighting Fantasy," but that name was taken by a tabletop role-playing game. "Final" was settled on as a way to reference not only Sakaguchi's intended last game but also Square's failing finances.

Double Dragon
1987

 BEAT 'EM UP **ARCADE**

Double Dragon is notable not for inventing a genre but for making it a worldwide sensation. Its refinement of the beat-'em-up genre, which has players punching enemies on a side-scrolling battleground, stood out in the gaming landscape of 1987—even next to heavy hitters like *Final Fantasy* and *The Legend of Zelda*. It began as a hit arcade game, but its PC and home console ports are what really cemented its popularity, inspiring sequels and legions of beat-'em-ups to follow.

The game, developed by Technōs Japan and published by Taito, introduced several improvements over earlier beat-'em-ups like *Kung Fu Master* and *Bruce Lee*. While previous games were largely punch- or kick-based, *Double Dragon* included a greater arsenal of attacks, such as throws, and even allowed players to pick up enemy weapons in order to make the combat feel more like a martial arts movie.

The name *Double Dragon* is a reference to both the star-making Bruce Lee film *Enter the Dragon* and another of the game's major innovations: a two-player co-op mode that allows players to fight together against the many enemies.

The Famicom/NES version of the game was actually very different from the original game. The co-op mode was removed, and one of the two player characters, Jimmy Lee, became the game's primary antagonist. The NES version also had fewer enemies on-screen due to technical limitations, but players still enjoyed the at-home version of the beloved arcade game despite its many changes.

Mega Man
1987

ACTION

NINTENDO ENTERTAINMENT SYSTEM (NES)

In 1987, Capcom was a well-established arcade developer that also produced successful home console games like *Ghosts 'n Goblins* and *Street Fighter*. However, *Mega Man*, called *Rockman* in Japan, was the company's first attempt at a home-exclusive title. To accomplish this risky feat, it brought in a team of relative newcomers to work on the game in the hopes of infusing it with a sense of freshness compared to the other games on the market.

One of the most unique innovations this team introduced was the concept of gameplay inspired by Rock, Paper, Scissors. Each equippable weapon had a different strength and gave the main character, Mega Man, superior power over one type of Robot Master. Throughout the game, players defeated enemies not by leveling up or combining established tricks in new ways, but by experimenting with weapons to see which was most effective.

Though a critical success, *Mega Man* wasn't a strong seller because of some internal fumbles. First, Capcom commissioned an English release after a modest success in Japan, but the localization process was rushed. The cover of the game's American version was also famously bad, having been drawn in just six hours. Artist Kenji Inafune blamed the box art as part of the reason for the initial lack of popularity in the United States. Over time, however, the game's reputation for quality, spreading through word of mouth rather than through official marketing, earned it a larger audience. In 1991, Capcom re-released the game thanks to an outpouring of fan demand, giving the series a second chance at life.

Rockman, the Japanese title, was changed for the American release. Capcom's senior vice president at the time, Joseph Marici, who thought that the original title was "horrible," coined the new name, *Mega Man*, himself.

SimCity
1989

 SIMULATION **COMMODORE AMIGA/ MACINTOSH**

Drawing inspiration from earlier games like *Fortune Builder*, Will Wright's *SimCity* was far from the first simulation game. What made it unique was the way that it combined the innovations of previous games with a lack of fail states—meaning players would never see a "game over" screen indicating they'd lost—and Wright's desire to make the act of creation fun.

While working on *Raid on Bungeling Bay*, Wright discovered that he was enjoying designing the levels more than he was actually playing the game. He combined the pleasure of editing levels with some theory on urban planning, courtesy of Jay Wright Forrester's work, and the genesis for *SimCity* was born.

Despite its originality, *SimCity* was a difficult game to pitch, and Wright was unable to find a publisher, so he founded Maxis with Jeff Braun to self-publish the game.

Because the game was entertaining even if players weren't technically skilled at it, *SimCity* was a widespread hit, though it took *Newsweek* covering the game to get it mainstream attention. Within three years, it had sold one million copies and launched Wright's career as a game developer.

Maxis was transparent about its founders' political interests and how those interests were manifested in *SimCity*. According to Jeff Braun, Maxis was "pushing political agendas," including Will Wright's interest in public transit and his dislike of nuclear power.

Mother
1989

RPG

FAMICOM

Having begun from the tradition of *Dungeons & Dragons* and earlier games like *Ultima* and *Zork*, role-playing games until 1989 had been associated with fantasy. That was until Shigesato Itoi, a celebrity copywriter in Japan, had a different idea: a contemporary RPG that wasn't fantasy but was still infused with magic powers. He pitched the game to Nintendo's Shigeru Miyamoto, and Miyamoto approved, despite some misgivings about Itoi's lack of experience and the trend of bringing celebrities into unrelated fields for star power rather than talent.

Though Nintendo received criticism for hiring a copywriter rather than an established game writer, the resulting game, *Mother*, was a success because of its deliberate and purposeful subversion of RPG expectations and its original design. However, despite its popularity, an English version was deemed commercially unviable. Nintendo thought that localization would be too difficult because of Nintendo of America's content

restrictions. The technical limitations of the NES were also an issue, as *Mother*'s sprawling world and extensive dialog proved too challenging for an English version. With the impending release of the Super Nintendo, which would require an entirely new version of *Mother* due to hardware differences, the company believed that adapting the game wasn't worth the effort.

Even the incredibly successful release of *EarthBound*, the 1994 sequel, was not enough to convince Nintendo to release the first game. An English prototype of *Mother* was built, then abandoned, and later auctioned off and purchased by someone who uploaded it to the internet in 1998. This prototype was circulated as *EarthBound Zero*.

It wasn't until 2015, some twenty-six years after the game's original debut in Japan, that *Mother* finally saw a worldwide release.

EarthBound Zero helped kick off interest in emulation, which allows people to play games on a system, such as a PC, that they were not originally developed for. People wanted to play *Mother* but could not, so they used a computer to run the English prototype with an emulator. Though illegal in many cases, video game emulation is hugely important for preserving games that might otherwise be lost to hardware degradation.

The Secret of Monkey Island 1990

 ADVENTURE **COMMODORE AMIGA**

King's Quest established the graphic adventure genre, but it wasn't without its flaws. The puzzle difficulty and frequent deaths frustrated many players, including Ron Gilbert, a self-taught game designer. In response, Gilbert pitched a game about pirates to Lucasfilm Games and joined up with designers Tim Schafer and Dave Grossman to work on the project.

Instead of emphasizing difficult puzzles, as was the case in *King's Quest*, *The Secret of Monkey Island* made great use of clever writing and mechanics, as well as one of the first instances of a "dialog tree" to entertain players. As the hapless aspiring pirate Guybrush Threepwood, players solved puzzles and interacted with other characters throughout the game's humorous setting, which included sword-fighting scenes that were driven by insults rather than quick button-presses.

Ushering in a new era of adventure games, *The Secret of Monkey Island* was well received by critics and players, but was only modestly successful for the company.

Sonic the Hedgehog
1991

 PLATFORMER

 SEGA GENESIS

Though Sega had been part of the video game industry for some time, it had yet to reach the level of popularity of companies like Nintendo and Atari. Looking to compete with Nintendo in particular, Sega president Hayao Nakayama put together a team that included designer Hirokazu Yasuhara and programmer Yuji Naka to create a mascot that would be as iconic as Mickey Mouse and would come with a game to sell it. The new mascot would replace Sega's current one, Alex Kidd, who was thought to look too similar to Mario.

The game was intended to be like *Super Mario Bros.*, but far faster and simpler. Instead of a multitude of buttons, players would primarily interact with the game through the directional pad and the jump button in order to make gameplay feel much faster than normal. It worked, and the

game, led by a blue hedgehog with an attitude, became *Sonic the Hedgehog*.

For the first time, Sega was able to compete with Nintendo. In 1991, the Genesis outsold the Super Nintendo two to one (Nintendo eventually regained its lead in the mid-1990s). More important, *Sonic the Hedgehog* established Sega's brand as a little edgier, a little faster, and a little more mature feeling than the other consoles on the market.

The mid-'90s was a time of great rivalry for Sega and Nintendo. As part of its attempt to dethrone Nintendo from its position as the top-selling console company, Sega went for the jugular in its marketing campaigns, hitting every one of Nintendo's weak points. Sega's ads were vicious and direct, with taglines like "Genesis does what Nintendon't"—and it worked. Between the innovations of *Sonic the Hedgehog* and the intense marketing campaign, Sega was able to seize its own corner of the market from Nintendo.

Street Fighter II:
The World Warrior
1991

 FIGHTING **ARCADE**

The original *Street Fighter*, released in 1987, was a successful if somewhat unmemorable fighting game. The sequel, *Street Fighter II: The World Warrior*, was a sensation. Its streamlining of fighting mechanics, as well as the accidental introduction of combo moves, made the game a runaway hit in arcades, where it almost single-handedly revived the arcade industry during a serious lull.

Capcom, hoping to bring the *Street Fighter* series back into prominence, spent around ten months designing the follow-up, with a particular emphasis on animation quality. The game's balance—referring to fine-tuning the mechanics of each character to be roughly equivalent in terms of strength—wasn't a serious issue for the designers, and producer Noritaka Funamizu said that it was the animations, not necessarily the gameplay, that were likely responsible for *Street Fighter II*'s success.

The combo system, which allowed players to string together attacks that couldn't be blocked, was the first of its kind, in part because it was a total accident. Funamizu discovered during a bug check that, with accurate timing, a player could follow one punch with another, leading into an unbreakable series of hits. Since the timing was so specific, Funamizu didn't believe it would be discovered and exploited by players. On the contrary, *Street Fighter II*'s combo system became the series's defining feature. It was expanded on in every sequel and adopted into multiple other competitive fighting games.

The characters Balrog and Vega have different names in the Japanese version. Balrog, a Black boxer, was designed as a reference to Mike Tyson and was originally named M. Bison, short for Mike Bison. To avoid a likeness-infringement lawsuit, they changed his name to Balrog, the name of the claw-handed fighter in the Japanese version, and gave the name M. Bison to the final boss.

Catacomb 3-D
1991

 FIRST-PERSON SHOOTER **MS-DOS**

It's the third game in the *Catacomb* series that is arguably the most famous, not necessarily because of its innovations—which *were* important—but because of what it led to. Previous *Catacomb* games had been top-down, third-person action games in which the player controlled a wizard firing spells at enemies. The team behind *Catacomb 3-D*, who later founded id Software, were reportedly inspired to create a detailed, texture-mapped game after witnessing a demo of *Ultima Underworld* at CES, an industry trade show. According to one of the *Ultima Underworld* developers, John Carmack said that he could develop a game with faster texture mapping than *Ultima Underworld*, and that project became *Catacomb 3-D*.

It wasn't just the 3D graphics and texture mapping that made *Catacomb 3-D* such an important game; it was how the graphics were implemented. By combining a first-person

perspective with 3D graphics and the player's ability to shoot spells from the character's hands, id Software arguably created one of the original first-person shooters. The game also contained an hourglass item that would slow down time, allowing players to fire multiple shots while the enemies couldn't respond, making it also the earliest example of a "bullet time" mechanic.

All these foundational improvements led to refinements of other games like *Wolfenstein 3D* and *Doom*, two games that defined and popularized the first-person shooter genre—and both of which were also created by id Software.

Sid Meier's Civilization
1991

TURN-BASED STRATEGY

MS-DOS

Civilization was a popular board game that seemed to be perfect for a video game adaptation, but attempts to develop it frequently ended in frustration. At least two efforts were made prior to Sid Meier and Bruce Shelley's version, but neither was completed. Inspired by their previous work at MicroProse on games like *Railroad Tycoon*, as well as by the success of *SimCity*, Meier and Shelley built *Civilization* on the premise of multiple interconnected systems, turn-based strategy, and an adherence to fun over accuracy. They introduced computer AI enemies, which ramped up the stakes for players, and also provided multiple avenues for success so that a civilization couldn't fall on its own. Players could seek victory through military conquest, scientific achievement, or pure point accumulation, making it easier for all kinds of people to enjoy the game.

Civilization is also famous for introducing and adopting one of the most iconic video game glitches. Because Gandhi, one of the game's world leaders, had an aggression rating set to one, any attempt to reduce his aggression further would reset his aggression to the highest possible level. This resulted in Gandhi being particularly prone to nuclear attacks—a bug so strange and hilarious that it became a feature.

The Gandhi bug was a huge hit for the franchise, its absurdity delighting players as often as it frustrated them. In later *Civilization* games, Gandhi is deliberately programmed to respond as a warmonger. Because later versions have more complexity, Gandhi is often programmed to have a low warmonger rating but a high nuclear weapon rating. He's unlikely to start war, but, when pushed, he'll respond by dropping nukes without hesitation.

Mortal Kombat
1992

 FIGHTING **ARCADE**

Street Fighter II set the stage for what fighting games were capable of, but Ed Boon and John Tobias wanted to take the genre even further. Though they may not have realized it at the time, *Mortal Kombat* changed the future of gaming by taking fighting games in a more adult direction.

Early in the game's development, two major changes were made that would distinguish *Mortal Kombat* from *Street Fighter* and its numerous clones. The first was the use of digitized rather than animated graphics, which gave *Mortal Kombat* a more realistic feel. Boon and Tobias both disliked the "dizzying" mechanic that many other fighting games used, which froze players in place after a certain number of blows were taken. They also moved the dizzying to the end of the fight, giving players the opportunity to execute complex combos against their enemies with gruesome animations called "fatalities."

Fatalities are what sealed *Mortal Kombat*'s influence on the video game industry. Not only was Nintendo's version of the game sanitized of the violence to preserve the company's family-friendly image, but the violence was also key in the formation of the Entertainment Software Rating Board, or ESRB. When Senator Joe Lieberman planned to bring questions to Congress about over-the-top violence in *Mortal Kombat* and *Night Trap*, the ESRB was established to regulate ratings from within the industry just a few hours ahead of the hearings.

Nintendo, due to its policy against objectionable content, did not allow *Mortal Kombat* to be released on the Super Nintendo until the blood was recolored to look like sweat. However, this change meant that the Sega Genesis version, which allowed players to turn on the blood with a well-known cheat code, outsold the Nintendo version by millions of copies. During the video game violence hearings of the mid-1990s, Nintendo claimed that it was doing its part to mitigate some of the potential damaging effects of violent games by removing the blood from *Mortal Kombat* while companies like Sega were not.

Virtua Racing
1992

 RACING **ARCADE**

Because one of *Virtua Racing*'s biggest innovations was also responsible for some of its inaccessibility, remarkably few people have played the game that defined many of the arcade racing genre's core features. *Virtua Racing*, which started as an arcade game, was a huge improvement over other racing games thanks to its advanced graphics. It also introduced racing-game staples like animated pit crews and the ability to switch point-of-view at will, allowing players to drive in first-person view, driver's-eye view, or a classic third-person view.

However, all this came at a cost. New *Virtua Racing* arcade machines cost around $18,000, and by 1992 the arcade industry wasn't thriving the way it had been in previous decades. Expensive machines like *Virtua Racer* were found only in Sega arcades, meaning that large portions of the population would never experience the game in arcade format.

Sega did create a Genesis port of the game, but even that came with drawbacks. Sega was porting a thirty-two-bit game to a sixteen-bit console, which required some hardware finagling and the use of a new chip, called the Sega Virtua Processor (SVP). However, the SVP wasn't enough to effectively port the game; the Genesis simply couldn't render the necessary colors, making the game look choppy and unimpressive. View distance was decreased due to the inability to effectively render distant polygons, which made first-person view difficult to play. Worse, the technological improvements came at a higher price tag. The game had a minimum price of $100, making it the most expensive Genesis game to date, especially for a five-year-old console. Though it didn't have the reach of many of the games that would eventually build on its foundation, *Virtua Racing* was nonetheless an important game for the genre.

Alone in the Dark
1992

SURVIVAL HORROR

MS-DOS

Alone in the Dark was the game that changed the horror genre forever. Building on the traditions established by games like *Sweet Home* and even nonhorror games like *Castle Wolfenstein*, *Alone in the Dark* added a new feature: 3D graphics.

Despite incorporating a mixture of 2D and 3D images, it's considered the first example of a 3D survival horror game—a genre characterized by limited resources, an atmosphere of dread, and frightening enemies. The 3D perspective would later become the standard for horror games, and *Alone in the Dark* was hugely influential on genre juggernauts like *Resident Evil* and *Silent Hill*.

Players are given the choice of a male or female protagonist to navigate an eerie mansion in search of a prized piano. In a story steeped in traditions pioneered by horror masters like George Romero, H. P. Lovecraft, and Clark Ashton Smith,

players encounter horrific monsters and fiendish puzzles as they unravel the mystery of the mansion.

Director Frédérick Raynal, a longtime fan of cosmic horror and zombie films, conceived the concept for *Alone in the Dark* when Infogrames CEO Bruno Bonnell suggested a game in which players would navigate a dark place using only matches that would quickly burn out. Though Raynal wanted the game to make use of 3D technology, he was unconvinced that computer graphics could capture the right atmosphere of horror. To solve this, *Alone in the Dark* makes heavy use of text to create its tense and eerie setting in conjunction with the visuals, fixed camera angles, and slow pacing.

Dune II:
The Building of a Dynasty
1992

REAL-TIME STRATEGY

MS-DOS

Building on the foundation laid by Maxis's *SimCity* three years earlier, *Dune II: The Building of a Dynasty* came to define the real-time-strategy (RTS) genre. Though it's called *Dune II*, it bears little resemblance to the first game in the series due to license changes throughout its development.

The owner of the *Dune* license at the time, Virgin Interactive, planned to cancel the *Dune* game that Cryo Interactive was working on after some concern about the mechanics and opposition to the game's "French aesthetic." But as the license holders, they needed to find a new use for the property, and after witnessing the fast pace and enjoyable strategy of *Herzog Zwei*, Virgin Interactive approached Westwood Studios' Brett Sperry to create an RTS game with the *Dune* license. Sperry believed that the Cryo game was canceled, but the company did finish the game, publishing it as *Dune* and leaving Sperry's game to be called *Dune II*

despite its having little to do with the first game other than the setting and license.

Regardless, *Dune II* made its mark. It introduced a hybrid keyboard and mouse input system inspired in part by the Macintosh operating system, giving players more control and finesse in interaction. Sperry also introduced more intuitive design to the RTS field, as the genre requires advanced controls and precision that were not yet standard. That meant Sperry's design had to be easily understood to be playable in real time—players had to learn the controls quickly or the game would simply carry on in real time without them. The tight design and control scheme became the standard for not just RTS games but computer games as a whole, going on to influence future games like *Warcraft* and *Command & Conquer*.

Myst
1993

 GRAPHIC ADVENTURE **MS-DOS**

Brothers Rand and Robyn Miller most likely didn't anticipate that their game, *Myst*, would be hailed as the death of the adventure genre, the birth of the casual game, or an early example of the "walking simulator"—a narrative-heavy, exploration-driven genre that would come to prominence in the 2010s. *Myst* was unusual for its time. Rather than being action oriented, the game had players explore a mysterious island and discover the story as they solved puzzles using logic. The story, more serious and adult than those that had come to dominate the adventure genre, was slower and thought provoking, exploring the relationship between games and books as storytelling media. Players rescued characters trapped in books, solving puzzles not through pointed commentary and jokes, but through exploration and experimentation in a somewhat surreal setting.

These innovations are precisely why *Myst* was the catalyst for so much change in the industry. In addition to the uniqueness of its story and mechanics, *Myst* also helped drive the adoption of the CD-ROM format. It became the first CD-ROM to sell over one million copies and remained on the best-seller list for three years. In fact, *Myst* was the best-selling game of all time until *The Sims* achieved that status in 2000, cementing its influence on story-driven games to come.

The game's sound effects weren't made through traditional means. To simulate fire crackling, sound designer Chris Brandkamp drove over gravel because it sounded more like fire than actual recordings of fire. Likewise, the sounds of a clock tower were made using a pitched-down recording of a wrench being struck against an unknown object.

DEATH OF THE
ADVENTURE GAME

Myst did some incredible things for the gaming industry: it became one of the best-selling computer games of all time, it pushed the boundaries of the adventure genre, and it solidified the CD-ROM as a viable format. But, like any major success, it also had some drawbacks. Low-quality clones—remakes, rip-offs, and straight-up plagiarized versions of the popular game—flooded the market. As a result, players grew increasingly skeptical of the genre. If companies were churning out poor-quality *Myst* clone after poor-quality *Myst* clone, where could consumers turn for reliable quality? Though many iconic and high-quality adventure games were released after *Myst—I Have No Mouth and I Must Scream*, several *Discworld* games, and *Broken Sword*, for example—the genre was on a distinct downward swing.

Adventure games were known for looking and playing a particular way, but faced with consumers' eroded confidence, companies began chasing industry trends to recapture the market. Full-motion video games, which used prerecorded video in place of illustrations

of computer-generated models, became the new trend to capitalize on the increasing popularity of realistic graphics. Unfortunately, the results were less than stellar—*Phantasmagoria* and *Night Trap* being two popular examples of how technological improvements don't necessarily equate to better games.

By the mid-'90s, adventure games had largely fallen from popularity. Even Sierra's *King's Quest* bought into the trends, with *King's Quest: Mask of Eternity* embracing 3D graphics and taking a pummeling both critically and commercially as a result. Sierra was bought out in 1998, but it never really recovered from the financial hit and was shuttered in the late 2000s. LucasArts's *Grim Fandango*, released in 1998, was one of several attempts to revive what many considered to be a dying genre. Though it was critically praised, it sold fewer than a hundred thousand copies in its first few years, and the company stopped releasing games in 2013 after being purchased by Disney.

Things truly did seem dire for the adventure genre. However, *love* for the genre never died, and when digital game distribution became more sustainable and popular in the early 2000s, developers from companies like LucasArts began producing independent adventure games under new companies such as Double Fine, Telltale Games, and Wadjet Eye Games. These

companies, along with numerous other indie developers, revived the adventure game genre from its stagnant, but never really *dead*, state. Today plenty of developers are creating fascinating new takes on the genre—embracing niche markets, experimental technology, and unusual release schedules to reach a new generation of adventure game fans.

❖ ❖ ❖

Doom
1993

 FIRST-PERSON SHOOTER **MS-DOS**

Though *Catacomb 3-D* may have been id Software's first foray into the first-person shooter, it's *Doom* we have to thank for the standards it set for the genre. Aided by id Software's shareware distribution approach (the company released the first part of the game for free, including a version that allowed for local area network multiplayer, with a request to send money for the rest) *Doom* spread rapidly throughout the gaming community and eventually sold over two million copies.

However, it wasn't just shareware that propelled the game to success. Following the establishment of the Entertainment Software Rating Board in 1994, *Doom* was the first to receive an "M for Mature" rating due to its extreme violence. Id Software was making the game that they, as metal fans and horror enthusiasts, wanted to see. As it turned out, so did many other people. The controversy over the game's

gore and Satanic imagery helped stoke the fires of curiosity, and its addictive, fast-paced gameplay hooked players and kept them enraptured.

Inadvertently, *Doom*'s shareware release proved that free demos were good marketing as well. Though *Doom II* wasn't released as shareware, id Software did continue to release free tools for user-generated content, allowing players to keep creating and playing long after the core game's potential was exhausted.

Early in development, the team behind *Doom* disagreed about how much story should be present in the game. John Carmack was the most vocally against having a story, stating, "Story in a game is like story in a porn movie; it's expected to be there, but it's not that important." *Doom* did get made with a story, but Carmack's emphasis on technological experimentation is in fact what most people remember about the iconic title.

Warcraft: Orcs and Humans
1994

 REAL-TIME STRATEGY **MS-DOS**

Inspired by *Dune II*'s innovations in the real-time-strategy genre, *Warcraft: Orcs and Humans* infused the established conventions with a fantasy flair that would later become one of Blizzard's most defining features as a company.

Following *Dune II*'s release in 1992, there was a lull in the RTS market. Blizzard aimed to capitalize on that with an RTS of its own, bringing fantasy elements into the mix. In addition to the new setting for the genre, the design team for *Warcraft* also aimed to create new mechanics that would improve on the formula that games like *Civilization* and *Dune II* had pioneered. Blizzard's take on the genre included new play modes and integrated multiplayer, ensuring that no two matches would be the same. In *Warcraft*, players could capture and rescue units or start with limited resources in these new play modes, giving the game even more replayability and staying power over earlier RTS games.

Interestingly, despite Blizzard's modern reputation for developed lore, *Warcraft* had a minimalist approach. All the dialog lines were improvised in the studio, and the story was fairly simple—the Orcs traveled through a portal to Azeroth and engaged in warfare with humans in a struggle for power. It was this approach that would set the tone for what was to come; the personality in those improvised lines became a core feature of later Blizzard games and made the game's tone and characters as appealing as the mechanics.

❖ ❖ ❖

System Shock
1994

 ACTION-ADVENTURE

 MS-DOS

Some of modern gaming's biggest titles—*BioShock*, *Prey*, and *Portal*, for example—all share a common influence: 1994's *System Shock*. With innovative audio diaries, the atmospheric, sci-fi horror setting, and nonlinear structure, this game changed the industry forever.

The team behind the game, feeling burned out after rushing through the development of *Ultima Underworld II*, aimed to do something radically different while using a few of the same features that were already available. They wanted an immersive simulation that would emphasize player choice and emergent gameplay without the typical medieval fantasy setting. *System Shock* was set in the far future, putting the player up against a diabolical rogue AI named SHODAN. Using audio diaries, the player learns about the history of the space station they're exploring while fighting off SHODAN's minions with a variety of weapons and tactics.

The audio storytelling is one of the game's most iconic features. Developed to avoid the dialog trees of previous games, the audio allows the player to continue moving through the game without interruption, while the story is delivered to them. Today, this is a common feature of similar action-oriented games, allowing for atmospheric storytelling without the interruption of lengthy cutscenes.

Though *System Shock* wasn't quite a smash hit, it was well received by critics and fans for its originality and elaborate gameplay. The sheer amount of freedom players had within the confines of the space station encouraged new and experimental forms of gameplay as well as features that would define subsequent games for generations to come.

System Shock's audio diaries were inspired by Edgar Lee Masters's *Spoon River Anthology*, a poetry collection comprising epitaphs written by the residents of a fictional town called Spoon River.

Super Mario 64
1996

 PLATFORMER **NINTENDO 64**

Super Mario 64 is frequently counted among the best video games of all time, and for good reason. Though the graphics have aged and refinements have since been made to the open-world platformer formula, the game's polish and tight design are second to none. More than twenty years after its release, the game is still an outstanding example of its genre.

As the first *Super Mario* game with 3D graphics, *Super Mario 64* had to set a high standard. The game's development was pushed to the Nintendo 64 to take advantage of the controller's multiple buttons, which were necessary to direct the more complex movements needed for navigating the 3D space and controlling the camera, which was the first in the industry that the player operated. The launch of the Nintendo 64 was delayed to allow it to be the console's inaugural title.

The game's portal system, which has Mario jumping through paintings into themed worlds, was designed to allow for large, open spaces without putting too much strain on the hardware. Each level was designed almost like a theme park, with a central feature, such as a snowy mountain, dictating what kinds of activities players could do within that world.

Super Mario 64 took the open-world element and transformed it into something entirely new. There was little linearity, and players were free to explore with only a few limitations. Because it was 3D and included an analog stick, players had more control over navigation—something that defines the genre even today.

According to Miyamoto, the Boos that players encounter throughout the game were inspired by assistant director Takashi Tezuka's wife. Though she was a quiet person, she one day became furious at how much time her husband was spending at work, and the designers turned this into a game mechanic—the Boos shrink when the player looks at them, but grow and become frightening when the player looks away.

Crash Bandicoot
1996

 PLATFORMER **PLAYSTATION**

Development on *Crash Bandicoot* began before the release of *Super Mario 64*, but both teams were very interested in how to translate character-based platformers to 3D spaces. As Naughty Dog founders Jason Rubin and Andy Gavin drove across the country to move their staff to Los Angeles, they noticed that arcade game genres like fighting, shooting, and racing had begun to shift into 3D instead of the traditional 2D. However, at that point, there was no existing framework to build on; anything they did would have to be entirely new, and unlike Nintendo, Rubin and Gavin didn't have years of experience and tools to draw on.

The team debated which system would be best suited to their needs, including the Atari Jaguar and Sega Saturn, ultimately landing on the Sony PlayStation, which Gavin described as "a sexy company and a sexy machine." Because Sony was just entering the video game industry, it hoped

that Crash Bandicoot would turn out to be the company's mascot. Though that didn't happen, *Crash Bandicoot* did become a successful take on the 3D platformer, despite lacking *Super Mario 64*'s innovation. The game sold over six million copies and is still ranked within the top ten best-selling PlayStation games of all time.

Rubin and Gavin, thinking about how players would see the character they were playing, jokingly referred to their idea as "Sonic's Ass Game," referring to both the player perspective and the popularity of *Sonic the Hedgehog*.

Pokémon
1996

 RPG **GAME BOY**

Pokémon started out with a simple premise: Game Freak founder and game designer Satoshi Tajiri based the concept of catching monsters on his childhood love of bug collecting. His attempt to capture that sense of childlike joy also included a lack of "pointless violence" and stress because the game's battles don't leave any lasting effect on the Pokémon.

Tajiri brought the premise to Nintendo just as Shigeru Miyamoto was looking for a game that would make use of the Game Link cable for the Game Boy. Tajiri believed that *Pokémon* would be a great fit for this new application, especially since most of the current uses for the technology were competitive rather than collaborative, and his vision would let players trade and collect even more monsters. Two cartridges, *Red* and *Green*, were created to encourage players to use the Game Link cable.

Though they were immediately popular in Japan, it took an additional two years for the games to be released in America. Nintendo's Western localization team feared that the cute monster designs wouldn't appeal to American children and asked the *Pokémon* team to come up with more muscular and monstrous-looking creatures. Nintendo president Hiroshi Yamauchi refused, and the video games were released in 1998 alongside the anime adaptation and trading-card game. One year later, total US video game sales had increased by $1 billion. This is likely thanks to the *Pokémon* games' popularity among children, which was so intense that many schools banned the game and trading cards.

Nintendo is said to have spent over $50 million promoting *Pokémon* for its American release because it was afraid the game would be poorly received by a Western audience.

Resident Evil
1996

SURVIVAL HORROR

PLAYSTATION

Alone in the Dark and *Sweet Home* are typically credited with defining the survival horror genre thanks to the combination of stealth mechanics (e.g., limited ammo and vulnerable protagonists) with horror aesthetics, but it's *Resident Evil* that brought mainstream attention to the genre. *Sweet Home* creator Tokuro Fujiwara had wanted to make horror games that could stand on their own as a unique genre; however, due to hardware limitations, *Sweet Home* was not quite the game he'd hoped it would be. In conjunction with a team that would become part of Capcom Production Studio 4, Fujiwara, as producer, set out again to create a game that would be everything he wanted—*Resident Evil*.

Drawing inspiration from earlier games as well as the film *The Shining*, *Resident Evil* (called *Biohazard* in Japan) combined horrific imagery and creepy enemies with the thrill of exploring a threatening mansion. Instead of making

the player feel powerful, the designers limited resources like ammo, save points, and health to make the player feel nervous. Fujiwara said that *Resident Evil* was, in part, an attempt to capture the things he wasn't able to do with *Sweet Home*'s limited technology.

Though Capcom financed the game, it did not expect it to succeed commercially because horror games of this scale and production value had not really been attempted before. However, *Resident Evil* became the company's best-selling debut title, selling more than thirty-five million copies in just over ten years.

Despite the fact that *Resident Evil* was a Japanese game, American actors were used for the full-motion video sequences and voice acting. Japanese lines were recorded but never used. Because the developers were not native English speakers, some of the lines sound strange to English speakers—fans of the series have delighted in mocking lines like "You were almost a Jill sandwich!"

Diablo
1996

ACTION RPG

MS-DOS/ MICROSOFT WINDOWS

Many of Blizzard's early offerings have been eclipsed by juggernauts like *World of Warcraft*, but the games *Warcraft* and *Diablo* were the foundation on which the company's legacy was built. David Brevik, one of *Diablo*'s designers and programmers, wanted to create a turn-based RPG, but publishers repeatedly said no, claiming that RPGs were dead. Blizzard, having just released *Warcraft*, was interested in the idea and asked that it be real-time instead of turn-based and that it include a multiplayer option—and thus, *Diablo* was born.

Unlike many earlier RPGs, *Diablo* introduced the concept of premade characters. Each character fit certain classes and roles without a large degree of customization, making it easier for newcomers to jump in and enjoy the hack-and-slash, action-based gameplay without a steep learning curve.

The multiplayer option was another important part of *Diablo*'s success because, unlike most games, the networking system was online rather than local. The multiplayer service was free, but it was the first network multiplayer program to turn a profit due to the advertising supporting it. The success of the multiplayer system, as well as the revolutionary design of the action bars, paved the way for massively multiplayer online role-playing games to follow—like Blizzard's hugely popular and successful *World of Warcraft*, which would be released in 2004.

Though *Diablo* required a CD key to play, each game also came with a shareware version. That version, called *Diablo Spawn*, had limited features and just two levels, but it served to introduce people to the core gameplay and entice them to buy it.

Tomb Raider
1996

ACTION-ADVENTURE

SEGA SATURN

In 1993, long before 3D platformers were an industry standard, development on the game that would become *Tomb Raider* was underway. Though it was released after *Super Mario 64* and *Crash Bandicoot*, which were both credited with establishing the 3D platformer genre, it was *Tomb Raider* that would set some of the groundbreaking standards that would define the industry for years to come.

The title of "first playable female video game character" goes to Samus, but Lara Croft—originally Laura Cruz—was one of the pivotal female main characters of video game history because it was obvious to players that she was a woman from the start of the game.

With an innovative, film-like musical score, *Tomb Raider* had a cinematic, tension-fueled quality. Though the programmed musical cues were actually a result of time restrictions instead of an intentional element, they added emotional emphasis

to important moments, and the quietness of the rest of the game let other sound effects shine. The result was a tense and dramatic atmosphere, and something that later games in the genre would adopt and adapt.

Originally, *Tomb Raider* was intended to have a male protagonist. Throughout development, the character that would become Lara Croft went from being a single male character to a choice of two characters, one male and one female. The team eventually settled on the female version because designer Toby Gard preferred her, and having two choices would have doubled the amount of animation required.

Tamagotchi
1996

 DIGITAL PET

 HANDHELD

This small, handheld device, created by Akihiro Yokoi and Aki Maita, might not register as a video game to most people, but *Tamagotchi* was nonetheless highly influential on the industry because of its intense popularity and incredible sales. *Tamagotchi*, unlike many video games of its era, had a worldwide appeal that went beyond the core gaming audience because consumers didn't need an expensive console to play it.

The game allows players to care for a baby alien by feeding, bathing, and playing with it in order to raise it into an adult. Because it needs attention throughout the day, many schools in the '90s banned the devices to keep kids from being distracted during class.

Maita designed the digital "pet" to be something she could care for despite having a busy life and a small apartment. The device and game caught on and would also win her

the Ig Nobel Prize in Economics in 1997, further honoring the surprising fun of the device.

Even Shigeru Miyamoto, the director of Nintendo, was impressed with the game's popularity. Miyamoto believed that, despite the device's lack of graphics quality, *Tamagotchi* had "won" over *Super Mario 64* because of its sheer popularity. Though not even *Tamagotchi*'s incredible sales—over eighty million units since release—could overtake the Nintendo 64's success, Maita's device managed to outsell iconic titles like the first-generation *Pokémon* games and *Wii Sports*.

Harvest Moon
1996

 RPG SUPER NINTENDO

With a few exceptions, most RPGs up to this point were fantasy- and combat-based. That is, until Yasuhiro Wada had a different idea. After moving to Tokyo, he decided to create an RPG without combat that was based on his love of the countryside.

The result was *Harvest Moon*, a combat-free RPG that centered on farming, building relationships, and repairing a dilapidated farm over time. Instead of wielding a sword or gun against fantasy enemies, players spent time caring for digital animals and building up their farm and community while thwarting storms and other rural threats.

The game was, unfortunately, a hard sell and was almost scrapped when the development company folded and many of the staff were fired. In order to finish creating it, the remaining staff slept on the floor in sleeping bags for months and cut many desired features from the game,

including time constraints and the ability to marry and have children. It wasn't until 1999, when *Harvest Moon 64* was released, that those features were reintroduced. Wada stated that, out of the two games, this was the one that came closest to matching his original concept. Despite these setbacks, *Harvest Moon* proved that RPGs could be an incredibly diverse genre and sold nearly a million copies. Its success would also kick off the trend and eventually the new subgenre of farming simulators.

Many things were changed from the original Japanese release of *Harvest Moon* for the US version, including scrubbing all references to alcohol. Instead, players could make and drink "juice," which, despite its more family-friendly name, would still make characters drunk.

Final Fantasy VII
1997

 RPG PLAYSTATION

In 1987, *Final Fantasy* defined the RPG genre and the legions of games that followed it, and ten years later *Final Fantasy VII* defined the genre all over again. The game's development began during the Super Nintendo era; however, it was quickly discovered that Nintendo's consoles were going to be unable to support the game's intense technological demands.

Despite Square's relationship with Nintendo, which had been the main home for the long series of *Final Fantasy* games, *Final Fantasy VII* was developed as a PlayStation exclusive because it allowed Square to keep the frame rate high for 3D gameplay and also take advantage of the storage space available on the CD-ROM. Because of the game's exclusivity, people were more than happy to shell out money for a new console to get their hands on the impressive graphics, new mechanics, and beautiful music that

had become a staple of the series, leading to *Final Fantasy VII*'s reputation as "the game that sold the PlayStation."

Though it's the seventh core game in the series, *Final Fantasy VII* was the first to really succeed in America. It was the best-selling game in 1997—a spot that typically belonged to Nintendo's games—partially because of its use of new technology, but mainly because it had managed to bridge the unique desires of American and Japanese audiences in one game, which few RPGs had managed to do until then.

At the time of release, *Final Fantasy VII* was one of the most expensive video games of all time to develop, costing some $61 million, adjusted for inflation. It also required one of the largest staffs, with around 150 people working to create it during a time when a team of 20 people was the industry average.

GoldenEye 007
1997

 FIRST-PERSON SHOOTER **NINTENDO 64**

Prior to *GoldenEye 007*, everyone assumed that shooters simply didn't work on consoles, because the simple directional pad and limited buttons weren't sufficient for exciting shooting gameplay. That is, until the Nintendo 64 and its analog stick came along. *GoldenEye 007* made use of the Nintendo 64's revolutionary controller, pitting players against computer-controlled enemies in shoot-outs inspired by the recently released James Bond movie of the same name, as well as allowing them to take on their friends in local multiplayer matches.

The game was less linear than other games of the era and unusual for a number of reasons; for one, it was a licensed movie tie-in. Another reason it stood apart was that the designers left the level design and balance until late in the development cycle in order to focus on creating interesting virtual spaces. On top of that, the overall idea of a first-person

shooter on a console was so bizarre that its reception at the Electronic Entertainment Expo of 1997 was a disappointment. People were eager for a James Bond game, but not one as seemingly doomed to fail as a console first-person shooter.

However, *GoldenEye 007* ended up being a huge hit when it was released. Not only did it bring the shooter genre to consoles, but it also changed consumers' view of Nintendo, which until this point was primarily known for its family-friendly titles. Though *GoldenEye 007* is tame by modern standards, in 1997 it was the most violent game Nintendo had ever released. That didn't stop its popularity, however, and by 1999 it had sold over five million copies.

> *GoldenEye 007*'s designers were incredibly faithful to the film and went as far as using real blueprints from the movie's sets to design the different levels.

Ultima Online
1997

MMORPG **MICROSOFT WINDOWS**

Richard Garriott, creator of the *Ultima* series, long dreamed of a stable fantasy world inhabited by thousands of real players. Despite some friction between Garriott and the publisher, Electronic Arts, *Ultima Online* became one of the earliest examples of what massively multiplayer online role-playing games were capable of and was the first game to hit the landmark of a hundred thousand subscribers.

Garriott and EA clashed frequently, but their two biggest sticking points were about the game's online-only status and whether or not it should be pay-to-play. Both were unusual mechanics at the time, as MMORPGs were still a new field—*Ultima Online* used a subscription model, but others did not. The constant pushback from the publisher was likely what spurred Garriott and his team to leave the *Ultima Online* franchise after the game's release.

Famous even before its release, the game had a beta tester, known as Rainz, who was able to attack and kill Garriott's avatar, an unheard-of feat. Rainz was banned from the game when it later came to light that he was exploiting bugs rather than reporting them, which led to massive in-game protests. The launch did not go much smoother, with server crashes and rampant player killing, called PKing, limiting the fun new players could have.

Throughout the launch and after, the team provided constant updates that either addressed or fixed many of these problems. The designers encouraged role-playing and grouping up, which led to groups banding together and creating bounties to get rid of PKers, and the game also introduced a color-based morality system to indicate which players were virtuous and which were murderers. *Ultima Online* is often praised for popularizing "emergent gameplay," referring to the way players created their own stories and tasks within the system rather than being dictated by it.

Player killing, while annoying for early players of *Ultima Online*, became a huge draw of MMORPGs to follow. Games like *World of Warcraft* and *Guild Wars* have thriving player-versus-player communities where people hone their skills against one another rather than the many AI enemies.

Metal Gear Solid
1998

ACTION-ADVENTURE

PLAYSTATION

The third game in the *Metal Gear* series, *Metal Gear Solid*—which references its protagonist, Solid Snake, as well as its 3D graphics—is widely recognized as one of the most important stealth games in history. Features like the inclusion of distractions, line-of-sight tracking, and "alert mode" system established stealth as a distinct genre and built on the early innovations of games like *Castle Wolfenstein*.

Developed to be "the best PlayStation game ever," *Metal Gear Solid* made great use of the console's 3D graphics, allowing for greater realism and accuracy than many of the other games on the market at the time could offer. The development team also did extensive research into weaponry and police tactics—including attending demonstrations by the Huntington Beach SWAT team—combining their research with the game's unique technical specifications to create a game that hinged on realistic stealth and strategy. As Solid

Snake, players take on FOXHOUND, a Special Forces unit threatening to turn a giant, nuclear mecha against the United States. Rather than incorporating scenes of intense action, *Metal Gear Solid* had characters infiltrating FOXHOUND bases, hiding behind objects and using technology—or a cardboard box—to evade detection.

Hideo Kojima, director, designer, and one of the writers for the game, has since been hailed as a visionary thanks to *Metal Gear Solid*'s significant deviation from the norm. The game, which sold millions of copies, rocketed the stealth genre into the mainstream and set a new, serious tone for game stories to follow.

Dance Dance Revolution
1998

 RHYTHM **ARCADE**

Dance Dance Revolution was a huge hit in Japan on its release in 1998, drawing legions of kids and teenagers to arcades to participate in the fast-paced dancing gameplay.

The series started as an arcade game with an unusual conceit that drew in players by virtue of its creativity. Rather than using a standard controller, players move their bodies and stomp their feet on arrows in time with music and directional arrows displayed on a screen in front of them. Players made the gameplay their own by incorporating special moves, such as jumping, swapping places on the arcade machine, or playing with their hands instead of their feet. These theatrics made the game even more fun to watch, attracting spectators.

Despite its popularity in Japan, nobody was sure whether the game would catch on in America because the machines were so expensive and heavy—the whole apparatus weighed

some nine hundred pounds. A few machines existed outside Japan in the late '90s, mostly in California, and a PlayStation port became available in 2000, but it took until the mid-2000s for the game to really catch on in the United States with the release of *Dance Dance Revolution SuperNova*.

Because *Dance Dance Revolution* is such a physical game, it was used in school fitness programs in West Virginia to promote exercise in children.

The Legend of Zelda: Ocarina of Time 1998

 ACTION-ADVENTURE

 NINTENDO 64

Many games left huge, important marks on gaming as a medium, but few reached the heights of *Ocarina of Time*, which is often considered to be one of the—if not *the*—greatest video games of all time.

Like previous entries in the series, the game follows the adventures of Link, a young boy with a great destiny—he must get the mystical Triforce before the evil Ganondorf does. As Link, players explore an entirely 3D world full of terrifying enemies and lovable nonplayer characters like Navi, Link's fairy companion.

Originally developed for a peripheral disk-drive system for the Nintendo 64, *The Legend of Zelda: Ocarina of Time* was later converted into a cartridge to improve its performance. Despite running on *Super Mario 64*'s engine, albeit a highly modified version, the game features some huge differences from *Mario* and many other 3D games of the era. One such

feature was the camera, which instead of focusing on the main character was used to view and showcase the world. The second was the context-driven action buttons that allowed the player to complete many complex actions with limited buttons.

The game was so enticing that its preorders tripled the number of preorders of any other video game in history. Its popularity even influenced the sales of real ocarinas when people started picking up the instruments to play in real life as they'd learned in the game.

Some of the concepts intended for *The Legend of Zelda: Ocarina of Time* were used in *Super Mario 64* instead, particularly the puzzles. The *Mario* series was not traditionally heavy on puzzles, but because Miyamoto had so many ideas for *Zelda*, he added them to *Mario* since it was releasing first.

Half-Life
1998

FIRST-PERSON SHOOTER

MICROSOFT WINDOWS

Frequently cited as one of the best video games of all time, 1998's *Half-Life* reimagined what it meant to be a shooter game. Though many unique takes on the genre had been released since it was popularized by games like *Doom* and *Quake*, Valve wanted to make the first-person shooter experience deeper than it had ever been.

Mike Harrington and Gabe Newell, former Microsoft employees, hoped to infuse the expected fast-paced gameplay of the genre with the greater levels of attention and emotion that were traditionally given to games with heavy world building and character, both of which were unusual for shooters. To achieve this, they brought in Marc Laidlaw, a science fiction and horror novelist known for his book *The 37th Mandala*, to write the script for the game. They also ditched the static cutscenes that players were accustomed to and instead delivered the story through largely interactive

sequences, and they added puzzles and unique weapons to keep the game's combat fresh and challenging.

The result was a huge success. The team expected to sell some 180,000 copies across the game's life span, but by the end of 1998 it had already sold well over 200,000 copies and earned about $8.6 million. It was a huge critical success as well, hailed as "revolutionary" among first-person shooters. Since *Half-Life*'s release, many later games in the genre have aimed to capture its success by bringing in deeper, more complex world building, inventive weapons, and story elements to distinguish them from the pack.

Though initially focused on game development, today Valve is better known for its digital video game distribution platform, Steam.

Grim Fandango
1998

 ADVENTURE **MICROSOFT WINDOWS**

Myst was revolutionary for demonstrating the potential of first-person storytelling and puzzle games that had grown out of the graphic adventure game genre. Unfortunately, *Myst*'s success had unintended consequences: it brought about the perceived "death" of the adventure game as expectations began to shift toward serious, adult stories and more opaque gameplay. LucasArts, previously known as Lucasfilm Games and the company behind successful adventure games like *The Secret of Monkey Island*, decided that it wanted to revive the supposedly dead genre with *Grim Fandango*.

Intended to recapture the fun of LucasArts's early graphic adventures, *Grim Fandango* was given a budget of around $3 million, which was put toward the game's new 3D graphics and a brand-new engine. In fact, *Grim Fandango* was the

first LucasArts game since 1986 to use something other than the company's custom SCUMM engine.

The game was a critical success, though its sales were modest. Many believed its commercial failure resulted from a lack of interest in the genre, which led to the cancellation of the sequels of two other LucasArts games. Director and writer Tim Schafer left the company shortly after *Grim Fandango*'s release to form Double Fine Productions. He, along with other adventure game veterans, would usher in a new wave of adventure games in the 2000s.

Tim Schafer tried to reacquire the rights to *Grim Fandango* multiple times, but he didn't succeed until 2013, and only then with the help of Sony. Unfortunately, many of the game's critical files were inaccessible or corrupted and had to be recovered by asking former LucasArts employees, as well as modders, to help the team put together the 2018 remaster.

Baldur's Gate
1998

RPG

MICROSOFT WINDOWS, MAC OS

Since the rise of the RPG genre, there had been a few Western RPGs that made it big—such as *Wasteland* and *Ultima*—but by the late '90s things were starting to decline. Most popular RPGs, like *Final Fantasy* and *Dragon Quest*, were developed in Japan, and almost all of them were console-based.

So when BioWare, a company newly formed by two practicing physicians who loved video games, decided to make a PC RPG, it was taking quite the risk. With just one game under its belt, called *Shattered Steel*, and a brand-new, ambitious team, most of whom had never launched a game, BioWare set off to develop its take on the RPG, with an entirely new engine to power it.

Despite the odds being stacked against them, they pursued the idea of creating an RPG that could hold its own next to the Japanese heavy hitters. Inspired by *Wasteland*, BioWare

wanted to make a game that would have a *Dungeons & Dragons*—like feel but with all the features that modern technology would allow. They wanted players to be able to approach problems in multiple ways, and they wanted to include a hefty amount of lore to help immerse players in the world.

In actuality, their *D&D*-inspired concept was so good that when they approached Interplay Entertainment to publish it, they were granted the *D&D* license. With the blessing of the licensor and all the trappings of the beloved universe, BioWare's big risk would become the hit RPG *Baldur's Gate*. The license, along with the solicitation of fan feedback throughout development, was part of what led to the game's success. Despite low commercial forecasts, the game sold around five hundred thousand copies in two months.

Baldur's Gate, which borrowed the mouse-heavy controls of games like *Warcraft* and *Command & Conquer*, took about ninety person-years to develop. During the last six months, team members frequently pulled twelve-hour days, sleeping at their desks and surviving on pizza. According to Scott Greig, BioWare's first real employee, he was so burnt out after the game released that he couldn't eat pizza for a year and a half.

Shenmue
1999

RPG

SEGA DREAMCAST

Despite introducing numerous concepts that became staples in the video games that followed, *Shenmue* was an enormous commercial failure due to its sprawling ambition and limited release. Its lack of success is even said to have contributed to Sega's departure from the video game market after the company failed to recoup its investment in the game.

Envisioned as a revolutionary action-adventure game that was influenced by the storytelling depths of cinema and included a heavy emotional structure, *Shenmue* was initially planned as a sequel to *Virtua Fighter*. It was also expected to be the Sega Dreamcast's "killer app"—the game that would sell the Dreamcast console.

In order to achieve these lofty goals, the game included an enormous open world and real-time cutscenes, which forced the developers to create a completely new kind of data compression. The development of *Shenmue* was rumored to

have cost around $50 million, making it the most expensive game created at the time, which would ultimately play a part in its downfall. Fewer than three million Dreamcasts were sold worldwide, which meant it was impossible for the company to turn a profit on the console-exclusive game. Even in Japan, where RPGs are extremely popular, only 20 percent of Dreamcast owners bought the game; it sold about two hundred thousand copies overall. However, its gameplay stood the test of time and turned the game into a cult success. Features like sprawling open worlds and quick time events became standard in games that followed. The sequel, which had been developed concurrently, was released in 2001. Thanks to a Kickstarter campaign and backing from the publisher Deep Silver, the third entry in the series was released in late 2019.

Shenmue's developers were very committed to the game's open world. More than twelve hundred rooms were designed with the help of real interior designers, three hundred characters with names and personalities were written, and real meteorological records were used to program the game's weather and daylight cycles.

Super Smash Bros.
1999

FIGHTING

NINTENDO 64

By 1999, fighting games had become a well-established, slightly unsurprising genre with a defined set of expectations. It wasn't until Masahiro Sakurai's concept for *Super Smash Bros.* that the genre would get the creative boost it needed. In Sakurai's game, players sought to knock each other off a stage rather than just KO them—an anomalous and revolutionary idea. To make it friendlier for newcomers and to avoid the standard of complex combo systems, the game used simpler, more streamlined controls that were fairly similar for all the characters.

While these adjustments, which also included mixing platforming into the traditional fighting formula, were big selling points, there was one additional thing that drew players to the new series. *Super Smash Bros.* featured characters from multiple Nintendo franchises and allowed players to pit them against one another in a chaotic, battle royale–style

fight. Though Sakurai didn't originally intend for characters like Mario, Ness, Pikachu, and Yoshi to feature in the game, he knew that the game needed a hook to help it sell, and incorporating Nintendo characters could be exactly what was called for. He assumed he wouldn't get permission if he asked in advance, so he built a balanced prototype with the characters well before pitching and demonstrating the game to Nintendo. The risk paid off and the company approved the design, Nintendo characters and all. *Super Smash Bros.* went on to sell several million copies, offering an alternative to the more intense competitive scenes of other fighting games. That is, until *Super Smash Bros.* developed its own competitive scene, which continues to grow to this day.

Silent Hill
1999

SURVIVAL HORROR

PLAYSTATION

Silent Hill was a huge milestone in the horror genre, but most people don't know that it was the product of several Konami designers who were on the verge of leaving the company. The game's development team largely comprised people whose previous projects hadn't worked out, and many of them were feeling frustrated and creatively stifled. In response, Konami shunted them out of the more profit-focused divisions and into the limited 2D department. What the company didn't anticipate was the level of artistic freedom the designers felt they had, especially because most chose to ignore some of the company's limitations and do their own thing.

The result of this conflict is one of the most famous horror games in history. Drawing from psychological and Japanese horror, David Lynch films, and the occult, *Silent Hill* focused on a weak, vulnerable protagonist rather than the typical strong hero. Instead of fighting off enemies with shotguns,

Harry Mason explored the decaying, fog-filled downs of Silent Hill in the hopes that he'd never encounter any monsters, given his relative helplessness and his unreliable aim.

Though it came from humble origins and was created by the black sheep of Konami, *Silent Hill* was well received by critics and sold over two million copies. Its success endured with the launch of a growing franchise of sequels, films, comics, and books that continue to inspire and terrify players to this day.

The fog, one of the game's most iconic features, was originally included to obscure the game's hardware limitations.

EverQuest
1999

 MMORPG **MICROSOFT WINDOWS**

Ultima Online might have set the stage for the success of MMORPGs, but it was *EverQuest* that claimed the market. Conceived by John Smedley in 1996 and created by Brad McQuaid, Steve Clover, and Bill Trost, *EverQuest* drew heavily from the MUDs of the '70s and '80s to capture the feeling of playing a tabletop game like *Dungeons & Dragons* and translate it for online play. The game was developed in full 3D, taking the gaming experience to the next level and leading to an incredible degree of immersion, especially for the era.

Despite Sony's investment of millions of dollars, expectations were modest. Few games like *EverQuest* existed, but its biggest competitor, *Ultima Online*, already had two years under its belt. However, the limited hopes for the game, combined with its polish and the lessons learned from watching *Ultima Online*, paid off. Within a month *EverQuest* had sixty thousand

subscribers, solidly beating out its competitor, which had taken three months to reach fifty thousand.

EverQuest is notable not only for increasing the breadth of MMORPGs, but also for raising important questions about monetization, copyright infringement, and video game addiction, all of which are still important conversations happening in the industry. It also has become an important point of sociological study as researchers try to better understand our online lives, especially given how many people spend hundreds of hours in online games.

EverQuest ignited a debate about fan-created works when Verant, the game's developer, banned a player named Mystere after it was discovered that the player was writing dark, violent fanfiction stories about characters in the game. Players rallied and pointed out that some of the game's content—particularly a quest in which players had to murder a pregnant character—was almost as violent as Mystere's fanfiction. The quest was removed from the game. In 2006, Verant cofounder John Smedley wrote on his blog that there was more to banning Mystere than the fanfiction, but he did not disclose further details.

The Sims
2000

LIFE SIMULATION

MICROSOFT WINDOWS, MAC OS

The Sims, like many of Will Wright's games, including *SimCity*, *SimEarth*, and *SimLife*, was inspired by an unusual source: Christopher Alexander's book on urban design and architecture called *A Pattern Language*. Wright was intrigued by the concept of influencing human behavior through design, and he conceived *The Sims* as a way to turn that idea into play. The game allowed players to create and control their own virtual people, designing palaces or prisons in which their AI-assisted creations would live out their storied lives.

The game was initially a hard sell because it wasn't well received by a focus group, but Wright and his team found that if they shifted the focus onto the characters, rather than on the design aspects, the game was more appealing to players. With this new direction, *The Sims* became a kind of "virtual dollhouse" where Sims were able to visit one another's homes and form relationships. Players could

create more complex stories and design their own fun and sense of success within this framework.

Following blowback for a *SimCopter* Easter egg, in which scantily clad men appeared to hug and kiss one another on certain dates, Maxis, the development company, knew it had to do better in its next game. Designer Don Hopkins advocated for including same-gender relationships, pushing back against programming that caused characters to slap one another if they were kissed by a character of the same sex. Due to late feedback from Will Wright, programmer Patrick J. Barrett III included the possibility for same-gender relationships based on player behavior. This feature was revealed during the 1999 Electronic Entertainment Expo demo, when two female characters fell in love and kissed in front of the press.

The Sims was remarkably easy to modify, leading many players to try their hand at creating their own content for the game. After its release, Maxis added modding tools to make user-generated content even simpler to generate and use in the game.

Counter-Strike
2000

FIRST-PERSON SHOOTER

MICROSOFT WINDOWS

An unusual game, *Counter-Strike* was originally designed as a modification, or mod, of the game *Half-Life* instead of following the traditional route of being conceived and developed by a video game publisher and its team. Created by Minh "Gooseman" Le, who had previously developed mods for the *Quake* engine, the game was a team-based first-person shooter in which players fought one another as terrorists or counter-terrorists, rescuing hostages, protecting or disarming bombs, and escorting players from one area of the map to another.

Le developed the mod as a computer science student in the hopes that it would make him more appealing in the job market. *Counter-Strike* used the framework of *Half-Life* with updates to the story and modifications to the gameplay and mechanics to create something entirely new. Partnering with Jess Cliffe, Le released several beta versions throughout

1999 to get feedback from the community and improve the final version. The betas drew so much attention that Valve reached out to Le and Cliffe with a bid to purchase the game—as well as job offers—which they accepted.

Counter-Strike is unique because it was one of the first games to go from being someone's mod side project to a successful stand-alone shooter. It even introduced a few revolutionary features, like VAC, Valve's Anti-Cheat program, which bans players if they have been detected using cheat software. VAC is now used in many games and franchises, including *Call of Duty*, *Team Fortress 2*, and *Ark: Survival Evolved*.

Despite its humble origins, *Counter-Strike* has sold millions of copies, and it became the first video game to have a professional fantasy esports league. As Le hoped, his work on the program led to his holding many jobs in the industry, including positions at Valve, FIX Korea, Facepunch Studios, and Pearl Abyss.

CONCLUSION: CONTINUE?

This book contains over fifty years of video game history, and yet it only scratches the surface. We simply couldn't feature every important game in history, and we had to find a cut-off point. For us, that was 2000, the year that brought life simulation and a professionally produced mod of *Half-Life* to the gaming market.

But that's not an ending, it's a beginning. As home internet became increasingly common in the late '90s and early 2000s, the gaming market had to keep up, and as a result it changed forever. Valve pivoted from being a video game studio to creating and running Steam, the biggest digital-distribution platform for video games. With Steam came a wave of independently developed games, because large, traditional publishers could no longer act as gatekeepers.

Now indie developers had the freedom and ability to create and publish their own games, generating an entirely new market that continues to challenge the status quo. By 2019, the best-selling game of all time was *Minecraft*, an indie game primarily developed by

a single person. It has sold six million—plus copies more than *Tetris* and sixty-six million more than *Grand Theft Auto V*, which hold the number-two and -three spots on the best-seller list, respectively.

All the while, gaming has gone from being a niche interest to one of the biggest industries in the world. As of 2018, around 67 percent of people play video games, and the gaming industry has earned some $43 billion in revenue. The world of video games is changing and growing rapidly, and that makes it more exciting than ever.

The games covered in this book are fascinating, inspiring, and illuminating technical innovations that shaped the industry, but to stop here is to deny yourself some of the most interesting work the medium has to offer. Indie developers are pushing boundaries and creating games unlike anything we've seen, while AAA publishers create Hollywood-level stories in gorgeously rendered 3D. Originality and scrappy, creative developers aren't just things of the past; they exist today, and their work is more easily available than ever.

If you have a passion for gaming, it's worth knowing about the classic games that laid the foundation for the newer games to build off of, reimagine, and

improve on. That said, with the landscape of video games constantly shifting, it's just as important to take a look at what's occurring in the field today and tomorrow, because history is happening now.

❖　❖　❖